IDEA revolution

GUIDELINES AND PROMPTS FOR BRAINSTORMING
ALONE, IN GROUPS
OR WITH CLIENTS

HOW
DESIGN
BOOKS

www.howdesign.com
HOW Design Books
Cincinnati, Ohio

IDEA
revolution

BY CLARE WARMKE
DESIGNED BY LISA BUCHANAN

Idea Revolution. *Copyright © 2003 by Clare Warmke. Manufactured in China. All rights reserved. No other part of this book may be reproduced in any form or by any electronic or mechanical means including information storage and retrieval systems without permission in writing from the publisher, except by a reviewer, who may quote brief passages in a review. Published by HOW Design Books, an imprint of F&W Publications, Inc., 4700 East Galbraith Road, Cincinnati, Ohio 45236. (800) 289-0963. First edition*

07 06 05 04 03 5 4 3 2 1

Library of Congress Cataloging-in-Publication Data
Warmke, Clare.
 Idea revolution : guidelines and prompts for brainstorming alone, in groups, or with clients / by Clare Warmke.
 p. cm.
 Includes bibliographical references and index.
 ISBN 1-58180-332-X (pb : alk. paper)
 1. Creative ability in business. 2. Brainstorming. 3. Group problem solving.
I. Title

HD53 .W37 2003
658.4'001'9—dc21

 2002027569

Editors: Clare Warmke, Amy Schell
Editorial Assistant: Ava Mueller
Designer: Lisa Buchanan
Production Coordinators: Sara Dumford, John Peavler
Page Layout Artist: Rebecca Blowers

The credits on page 160 constitute an extension of this copyright page. The author would also like to acknowledge the other creativity publications quoted within this book: Fearless Creating, *by Eric Maisel (Jeremy P. Tarcher/Putnam);* Brainstorming, *by Charles Clark (Wilshire Book Co./Doubleday & Company, Inc.);* Thinkertoys, *by Michael Michalko (Ten Speed Press).*

ABOUT THE AUTHOR

Clare Warmke is the acquisitions editor for the HOW Design book line. At HOW, Clare has acquired and edited a wide variety of graphic design books, in addition to co-authoring the book *Powerful Page Design*. Currently, she also serves as creative consultant and entertainment writer for the women-centered Web site, SheLikesDVDs.com. Prior to joining HOW Design Books, she worked as a freelance writer for a variety of Web sites and magazines, including the international bilingual (Russian-English) publication *Woman and Earth Almanac*. Clare lives with her husband, Bryan Rosser, in Cincinnati, Ohio.

DEDICATION

I dedicate this book to the most creative person in my life, my husband, Bryan Rosser. Bryan is the only man I know who can spin bumper-sticker logic into philosophy, who writes pop-music jingles solely for his cats and who can reenact the entire original Star Wars trilogy using only juggling clubs.

ACKNOWLEDGMENTS

This book required a ridiculous amount of faxing, e-mailing, sifting and sorting, in addition to the usual editorial, design and production work. For her exemplary skill with filing systems, I'd like to thank fellow editor Amy Schell, who would have invented Post-it Notes if 3M Corporation never got around to it. For being an indispensable fax wrangler, I'd like to thank intern Ava Mueller, who will do amazing things once Tulane University unleashes her upon the world. I also give a big thanks to designer Lisa Buchanan—our team's right brain—for shaping this book with her vision. To John Peavler and Sara Dumford, I give my thanks for an impressive production job. Another thank-you to intrepid reporter Chris "Peaches" Vance, for being another set of eyes. I also extend my thanks to all the in-house experts here at HOW Design Books/F&W Publications who made this book possible.

Most importantly, I'd like to thank all the creative people who contributed to this book. Thank you for sharing bits of your gray matter with HOW Design's readers!

TABLE OF
Contents

Introduction

• • •

Each project presents an infinite number of design possibilities. The one you choose to pursue will be based as much on chance as on research, as much on what you saw on your walk to lunch today as on what the client said in your first meeting. The magic of creativity is that it takes all the disparate bits of your life and makes sense of them, combining them in ways no one else can, because no one else has your knowledge, personality or experience. The magic of the ideation process is that you start in a familiar place, but then take a twisting, turning path to a new destination.

The ideation process cannot be approached rationally. It's not logical; it's an intuitive process of exploration and openness, of appreciation and observation. Your mind simply calls on you to be present, to listen to what it tells you and implement its suggestions well, and to fill it with new sights and thoughts that will feed your later inspirations. But this doesn't mean that you are at the whimsy of your fickle mind, slated simply to wait until it pops forth with a new idea. You can coax it along.

The designers who share their insights in this book have come up with many ways to coax their minds into generating new ideas. They have identified their greatest creative challenges, and offer their most effective solutions in the form of creativity tips and brainstorming activities, complete with supply lists and real-life anecdotes. In the first section, see how other designers combat personal challenges like fear of failure or lack of inspiration, then move on to the career challenge solutions in the second section. In the final section, learn to cope with the day-to-day obstacles that hinder your creative process. Or, if you're looking for creative advice to help in a specific ideation environment, follow the icons on each page that indicate whether its contents refer to brainstorming alone, **a**, in groups, **g**, or with clients, **c**.

Just like the ideation process, this book provides many possible steps and solutions along the path to successful design. Some are brainstorming exercises, some are creativity anecdotes and others offer advice that will clear your path to idea generation. These steps do not have to be followed in order—in fact, inspiring solutions often come from a mind that wanders and hops, meanders and skips from topic to topic.

Through the industry-tested insights in this book, you can follow the path of your own idea revolution, picking up what pieces of advice are valuable to your current design dilemma as you go. This book encourages you to scavenge, to look, to explore, and to see the importance of choosing to be creative.

• • •

Personal
CHALLENGES

BRAINSTORMING IS AN EGOTISTICAL BUSINESS. IT REQUIRES YOU TO FIND A HEALTHY BALANCE BETWEEN THE CONFIDENCE TO FORCE YOUR IDEAS INTO THE OPEN, AND THE COOPERATION SKILLS TO MAKE THOSE IDEAS WORK IN THE CONTEXT OF OTHER PEOPLE'S NEEDS. SOME OF THE MOST UNRELENTING PERSONAL CHALLENGES TO A DESIGNER'S CREATIVE PROCESS RESULT FROM THIS EGO TUG-OF-WAR. IF A DESIGNER'S EGO IS TOO FRAGILE ON ANY GIVEN DAY, THEN FEAR OF FAILURE TAKES OVER AND CREATIVITY ENDS. OR, IF AN EGO SWELLS UNCHECKED, A DESIGNER COULD BULLY HER DESIGN STAFF OR IDEATION GROUP INTO IMPLEMENTING A SOLUTION THAT MIGHT NOT TRULY MEET THE CLIENT'S NEEDS.

CREATIVITY REQUIRES A WILLINGNESS TO SAY WHAT YOU THINK IN A BOLD, CLEAR VOICE, BUT IT ALSO REQUIRES A WILLINGNESS TO LET IDEAS EVOLVE WITH THE HELP OF OTHER PEOPLE'S BRAINS. IN THIS SECTION, LEARN TO WIN THE BATTLE AGAINST YOUR OWN EGO BY CONQUERING YOUR FEAR OF FAILURE, FINDING INSPIRATION, REMEMBERING YOUR INTRINSIC CREATIVE SKILLS, AND SHARING YOUR BRILLIANCE WITH OTHERS.

• • •

You will always be your own harshest critic. It's nice to think that we can simply switch off our anxieties and fears if we choose to, but reality and experience has taught us that not all anxieties are easily dismissed. Your income and livelihood as a creative professional—a person who is paid to present and implement good ideas—is in jeopardy when you let fears inhibit your expression. Since our fears cannot be casually dismissed, they must be managed.

Psychotherapist Eric Maisel, author of *Fearless Creating*, helps artistic professionals such as graphic designers find ways to manage anxiety so that their energy is used for the productive and satisfying art of creating, rather than the destructive and debilitating art of self-torture. "If your demons are such that they fill the room the instant you contemplate creating, your studio will be too dangerous a place to enter," Maisel warns.

If you wrestle with the demons of self-doubt or past wrongs, those fears eventually will affect your creative capacity. You may opt for the "safe" solution for your next design project. You may choose to implement a client's less-than-desirable sugges- tions, just because it would be scary to argue your solution's worth and possibly lose the contract. You may decide to follow the year's trendy design style for your next few projects, rather than following your vision. These concessions can happen subtly, almost unconsciously. But at the end of the year, you'll have a portfolio full of medi- ocrity, when if you'd found a way to manage your anxieties and perform at your actualized potential, you'd have a portfolio of pride.

Mikey Richardson at Amoeba Corp., like many designers, knows fear firsthand. He says the biggest block to his creativity is "fear that the idea isn't my best, that others may not like it, that I may not like it. Fear that it isn't the 'right' idea. Fear that the idea will ruin everything and I will be exposed as a hack. Giving birth to an idea can be a very stressful, heavy, scary process."

New ideas happen only with personal risk—risk of embarrassment, of failure, of fall- on-your-face incompetence. In his book *Brainstorming*, Charles Clark tells the story of a Harvard University president who was known for his revolutionary ideas in education. "It is significant," writes Clark, "that during his years at Harvard he kept a picture of a turtle on the wall of his office with the caption: 'Behold the turtle. He makes progress only when his neck is out.'"

• • •

Creative Challenge:
YOUR FEAR OF FAILURE IS INHIBITING IDEA GROWTH

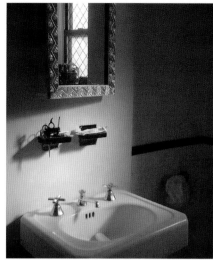

• • •

Many creativity experts agree that a person's best ideas can come when nature calls. This happens in part because bathrooms are a place of solitude and relaxation. You can simply blank your mind and stare at the stall door in front of you. Going to the isolation booth can do more than jump-start your ideas—it can give you a much needed rest in the middle of a harried day. As someone once said, "Going to the bathroom is god's way of saying, 'Just sit down for thirty seconds.'"

• • •

Designers who need to relax go here. A designer toilet gallery, clockwise from top: Conover's playful plant and magnet board; Jane Sayre Denny's elegant home studio; Lodge's TP pyramid; Artworks Design's mouthy stall door.

a ## Solution:
HIDE IN A RESTROOM STALL

Solution:
BE PREPARED FOR IDEAS

• • •

Lorie Josephsen of Otherworld Productions manages creative anxieties by being prepared for generating ideas. Her brainstorming process involves three planned-out steps: information intake, right-brain thinking, and seeing connections.

STEP 1: INFORMATION INTAKE

"Be sure you have all the information you need to solve the problem given to you. This includes the limitations of the project, the possibilities, the deadlines, everything. Also included in this step is taking in solutions to similar problems. If you are designing an identity package, then look at the best in identity package design in the past few years," says Josephsen.

STEP 2: RIGHT-BRAIN ACTIVITY

"To get you in your most creative frame of mind, give yourself time to do a right-brain activity," advises Josephsen. "At least an hour of drawing something from life will take you to that place, and then the ideas will start coming." Some other right-brain activities that Josephsen recommends are racquetball, walking, jogging, driving and cloud-watching. "Albert Einstein came up with his theory of relativity after watching patterns in the clouds, an excellent right-brain activity. Just sitting quietly watching movements in a river is also a great way to access your creative thinking patterns."

STEP 3: SEEING CONNECTIONS

"You may or may not get *the* answer during a right-brain activity or after one, but it will come at some point if you give it time. The key is organizing yourself so you can include structured creative time and then plan a time when you have to bring it all together," she says. "Notice when you actually get excited about an idea. That is the *Aha!* phase, when you are breaking through to something creative that just might work."

• • •

NECESSARY SUPPLIES

One page of paper (8½" x 11" inches), one magazine and one piece of music.

• • •

ACTIVITY

Occasionally, it makes sense to simply forget your design projects and create something for yourself. In this exercise, you will prepare a little book from the simplest of materials. It can be a good exercise for reconnecting with your individual creative approach.

The idea is that the music will inspire the style, coloration and texture of the book. There are no requirements for finishing details—messy, expressive responses are best.

REALITY

I teach a class at Seattle's School of Visual Concepts entitled "Creativity and Brainstorming." This is the exercise I assign the first week of class. This activity truly defines each person's creative approach.

• • •

PATRICIA BELYEA,
Principal, Creative Director,
Belyea

Three students, Shelly Pommer, Bronwen Williams and Lara Papadakis, created these books after the first week of Patricia Belyea's creativity and brainstorming class.

Solution:
ENGAGE IN INDIVIDUAL EXPRESSION

"SCARY IS GOOD."

—anonymous

NUMBER OF PARTICIPANTS
3–5. Any more and it's too many creative egos; less and people get bullied.

NECESSARY SUPPLIES
Creatives and a selection of "raw meat" concepts.

● ● ●

ACTIVITY
Roughly detail your concepts in preparation for presenting them to a group. Throw your ideas into the "lion pit" and prepare to have them ripped apart. Think about each idea this way: It's a raw-meat concept that's just too juicy and seductive for the group not to try to devour it.

After the feeding frenzy, pick up all the pieces that are left and bolt them together. Throw them back into the pit again. Repeat this as many times as you can before you either (1) feel suicidal; (2) feel like you don't want any more to do with the project and give it to the negative smartmouth in your studio who always talks everything down and never brings anything to the table; or (3) get something that makes you proclaim, "Good god, guys! That's smart as hell! Let's do it!"

REALITY
This approach happens very often at my studio. It's a nice way to keep designers on their toes and involved in other peoples' projects.

● ● ●

RICH MCCOY,
Head Tinkerer,
McCOYdotCOdotUK

Rich McCoy

Solution:
ACCEPT THAT YOUR IDEAS WILL BE RIPPED APART

g

• • •

If you're old-fashioned enough to keep a paper-based day planner or calendar, take a look back over your scribbled deadlines and appointments from the last year. What was that "Spe. G50, 9 am" scribbled onto August 28? Or the "AMJ noon" from January 5? At the time, those details seemed colossal, and you lived your life by them. Now, you don't even know to which project they refer.

Occasionally, it's a good idea to step back from the details and realize that your projects do not define your life. And have some fun with your occupation. As Mark Sackett from Sackett Design Associates puts it, "As designers, we can get so unbelievably serious about being creative, which is absurd. We're not landing planes; we're not doing open-heart surgery. Nobody dies from our design work, so let's make it effective, solve the problem, but above all, let's enjoy it."

• • •

a ## Solution:
PUT THINGS IN PERSPECTIVE

"CREATIVE MINDS HAVE ALWAYS BEEN KNOWN TO SURVIVE ANY KIND OF BAD TRAINING."
—Anna Freud

ACTIVITY

Don't play aimlessly, waiting for a "lucky accident" to arrive. I've seen a lot of designers start by playing with colors and type on their computers, moving it around endlessly, waiting for the right relationship to appear that creates a solution. The problem is that they often skip the fundamental step of coming up with an idea.

The mind has to be stimulated in some way for the sparks to kick in. Find an activity that is somehow related to the project at hand and just play with it, with no limits and no timeline. Have fun and let ideas come naturally.

REALITY

When designing the new Olive Web site, we wanted it to be rich with photography. We decided to shoot photographs of olives in context of other foods. We went to the supermarket and bought every kind of strange food we could: eggs, cereal, candy, fruit—anything and everything.

The magic really happened as we were shooting. We were playing with various elements, but we had a plan in mind. We opened up a box of chocolates and replaced a chocolate with an olive. We put an olive in a cracked eggshell as though it were hatching, etc., etc.

When we were finished we had a huge collection of great photographs. We looked through them and wrote lines of copy for them and then assigned them to various areas of the site until we had nearly completed the site.

• • •

STEPHEN FRITZ,
Principal, Creative Director,
Olive

Solution:
HAVE A PURPOSE TO YOUR PLAY

A photography plan—plus a little playfulness— resulted in an image-rich Web site for Olive.

Make a list of all of the people you admire. Next to each of their names, write down their admirable qualities. The list will probably include traits that you think you don't possess. In fact, that's probably why you admire these people—because they seem so capable in the areas that you feel so incapable.

Now you know your weaknesses. They are written on the page in front of you. In the same systematic way, you can transform your weaknesses into strengths. Each week, focus on one admirable trait that you'd like to adopt. Find opportunities to practice behaving in an admirable way. At first it will feel false, but as you begin to perceive yourself differently, the truth about who you are changes, too.

It helps in this exercise to also do an honest self-evaluation. Ask yourself these questions: What are my professional strengths? What are my professional weaknesses? What kind of work or project gives me a "victory buzz"? What have I done really well in the past? What haven't I done well, and what can I learn from those experiences? How do I think co-workers describe me? How would I like them to describe me?

"WHAT WOULD LIFE BE IF WE HAD NO COURAGE TO ATTEMPT ANYTHING?"
—Vincent van GOGH

Even the brightest stars of the design industry have other artists they admire. See who top designers consider worthy of respect:

a Solution:
BECOME THE KIND OF PERSON YOU ADMIRE

STEFAN SAGMEISTER ADMIRES ...

- Tibor Kalman, because he had more guts than any other designer I know, and understood that spending energy on making sure that a design appears as designed is as important as designing it.

- Makoto Saito for selling the same photo shoot to different clients.

- Rick Valicenti for continuously doing groundbreaking work.

- Paula Scher for designing her best project (the type for the New Jersey Performing Arts Center) after a thirty-year career.

BRUCE TURKEL ADMIRES ...

- Saul Steinberg, Le Corbusier, Carlos Segura, Herb Lubalin, Leonardo daVinci and Nancy Rice because their visual solutions are not only ingenious but because they make me look at things in a new way.

PELEG TOP ADMIRES ...

- Laurence Stevens of LSD in London. His typography and art direction have been a great force of inspiration to me for over fifteen years.

"AN IDEA CAN TURN TO DUST OR MAGIC DEPENDING ON THE TALENT THAT RUBS AGAINST IT."

—BILL BernBACH

Solution: a
MAKE A COMMITMENT TO ACCOMPLISHING IDEAS

• • •

How many times have you seen a new product and thought, "I could have come up with that!"? Or maybe you've seen a new product and exclaimed, "I had that same idea three years ago!" If you'd patented the idea then and acted upon it, you'd be the one making money today.

"Creativity is more than a great idea," says designer Patricia Belyea. "It's the determination to see the idea through to fruition." In other words, you have to be committed to making your ideas a reality. If you have trouble following through on your big, inventive ideas, have someone else hold you account-able. Make a list of ideas that you want to bring into reality within a year's time. Hand that list to a friend, co-worker or stranger, and ask them to call you in a year to check your progress.

• • •

NUMBER OF PARTICIPANTS
6–8

NECESSARY SUPPLIES
Two sets of Tinkertoys or other construction toys.

• • •

ACTIVITY
Explain to the group that this activity involves competition, cooperation and creative problem solving. It draws on every person's creativity.

Divide the group into two. Give each group a set of Tinkertoys and explain that the goal is to see who can make the highest structure within a given time limit. The tallest structure able to stand for at least two minutes wins. (If it falls before two minutes are up, the other team wins by default.)

Explain that after the activity there will be a short follow-up on the experience. Then set it up and watch what happens. Some people will want to work alone, some together. Some will plan the majority of the time, and some will want to get right to work. It's an exercise in cooperation.

By engaging in a friendly competition, the participants will focus on the activity rather than on straining to be creative. This approach bolsters confidence and allows them to be creative without realizing that was the goal all along.

During the follow-up, ask them what they learned and you'll see they have all kinds of interesting and creative answers and observations. After a break, get to the real creative dilemma—the design assignment—by telling them they passed the test as creative problem solvers and can now go on to tackle something more challenging. Their confidence will be up and they will attack the problem with less self-censoring.

REALITY
Having done this activity with clients, I was very surprised to see how delighted people were to discover how creative they felt after the activity. Equalizing everyone with an activity like this helps them to let go of trying to impress anyone. Since everyone is out of their experience range it feels fresh and new and gives a creative perspective.

• • •

LORIE JOSEPHSEN,
Director,
Otherworld Productions

Solution:
VALIDATE CREATIVENESS THROUGH COMPETITIVE PLAY

Lorie with her students and fellow brainstormers in the library of Brains on Fire, a graphic design company in Greenville, South Carolina. In order of appearance: Robin Randisi, Kenneth Sanders, Bart Boswell, Jessie Peterson, Reese Bowes, Lorie Josephsen, Raleigh Knox. Photo by Geno Church.

● ● ●

After a truly successful brainstorming session, it's often impossible to trace the origin of the best ideas of the day. Usually, the best ideas evolve under the collaborative effort of all the brainstorm participants. No one can step in and say, "But that was all *my* idea!" In fact, the moment you start to assign ownership to ideas, true creativity stops. Accept that the idea is bigger and more important than your ego needs. Plus, when you're the kind of person who can push an idea forward with your vision and collaboration skills, you will be recognized as the kind of person who makes things happen. You get the bonus of being credited as an "idea person" without having to trumpet through the hallways, "It was my idea! All mine!"

Designer Mark Sackett doesn't subscribe to the "this is mine, that's yours" mentality at his firm. "Any time a designer exhibits too much ownership over an idea, we try to share the project with other designers," he says. "Because what happens is, if they're going to have that kind of ownership over it, that means that they've closed the doors to many other possibilities." To bypass the resentment that could come from swapping projects like that, Sackett makes sure that his team works together and has equal opportunities. Everyone has an equal chance to work on each project that comes into their studio, and often a project is tackled by a small group of designers rather than just one designer.

● ● ●

Solution:
RELEASE OWNERSHIP OF IDEAS

g

Mark Sackett also runs Brainfood Creative Programs, a motivation and inspiration service for in-house marketing and creative departments. These mason jars, full of toys, trinkets and candies, are one of the tools Sackett uses to encourage idea generation.

• • •

In her work as a creativity coach for designers, RaShelle Westcott often advises designers to show the client the value of their work right away. Designers can head off a great deal of anxiety in a project if they establish their worth in a client relationship from the very beginning.

"We've got to educate the client. We've got to really enroll other people in the value we see in our own work," she says. "We need to communicate to the client in such a way that they can understand what they're going to get, what's going to happen in this process, and what the end result is going to be."

As we all know, when budgets get tight, "nonessential" services like design are among the first areas hurt. By speaking honestly with the client and emphasizing how your design work will enhance their business, you're not only enrolling them in the value of this particular project, but in the value of design as a part of their business.

• • •

RaShelle Westcott

a Solution:
SHOW OTHERS THE
VALUE OF YOUR WORK

"THAT WHICH IS CREATIVE MUST CREATE ITSELF."

-JOHN KEATS

• • •

"Most people need permission to be creative," says Mary Todd Beam, fine artist and author of *Celebrate Your Creative Self.* "In my classes, I start by giving the students permission. We will only validate creative efforts. There are no mistakes, only unrecognized truths." Even in a creative environment like a design firm, staffers can fall into old patterns. We've been taught since childhood to keep quiet and refrain from rambunctious, spontaneous activities that might result in a household lamp getting broken. If we feel as if our spontaneity and surges of ideas aren't being recognized or appreciated—as if we don't have permission to be creative—we can start behaving like a shushed child.

"Unplanned, spontaneous brainstorming sessions are usually the most productive ones," says Kelly D. Lawrence of Thinking Cap Design. "Some of our best design ideas and concepts have happened while passing in the hall. We'll chat about a project and then we notice our excitement building, so we take it further." Celebrate and encourage these free-wheeling idea sessions at your design firm. Send an all-staff e-mail when you hit upon a great idea, sharing the story of its spontaneous eruption and giving lots of thanks and credit to all involved. Or cancel a scheduled idea session in celebration of the spontaneous solution you had to another project, and let all the brainstormers look for ideas somewhere other than the company conference room.

• • •

Solution:
CELEBRATE SPONTANEITY

g

"Yes, we do have formal creative or planning sessions in the dreaded 'bored' room," admits Kelly Lawrence of Thinking Cap Design. "It's not too much of a problem if there are plenty of M&Ms. But our more creative ideas have come from unplanned discussions in the hall."

"JUST BECAUSE SOMETHING DOESN'T DO WHAT YOU PLANNED IT TO DO DOESN'T MEAN IT'S USELESS."
-THOMAS EDISON

• • •

If you feel like you can't possibly accomplish your list of goals and objectives, maybe the problem isn't with you. Maybe it's with your list. Some stress is necessary to keep us motivated, but as professionals, we tend to heap additional—and unnecessary—stress upon ourselves. Take a realistic look at what you are physically able to accomplish in a day. Once you've pared down your list to match reality, start making some plans. "Make lists, put stuff up on the wall," says Andrew J. Epstein of the Edward Lowe Foundation. "I set achievable goals for myself, then cross them off once I've reached them. This process lets me see tangibly that there is movement and I am not stalled."

• • •

a

Solution:
REDEFINE YOUR GOALS

"AN ARTIST IS NOT PAID FOR HIS LABOR BUT FOR HIS VISION."
—James McNeill Whistler

• • •

It's easy to forget the things you've done well, but remembering those triumphs will help you face future challenges. If you're able to say to yourself, "I've done other challenging projects in the past, and they worked out fine," then you're going to feel better about your ability to weather the next storm. Keep a record of all the things you've been proud of, and of all the praise you've received. It'll come in handy not only when you need a personal pick-me-up, but also when the boss says it's time for your review.

• • •

Solution:
KEEP AN ACCOMPLISHMENTS FILE

a

"ANY ACTIVITY BECOMES CREATIVE WHEN THE DOER CARES ABOUT DOING IT RIGHT, OR DOING IT BETTER."

—JOHN UPDIKE

Take a sneak peek in the accomplishments file of your fellow creative professionals:

BRUCE TURKEL'S ACCOMPLISHMENT:
"That people ask me for ideas in all sorts of creative endeavors (music, interior design, branding, stories, etc.) and not just graphics."

PELEG TOP'S ACCOMPLISHMENT:
"My most recent project. Every one of them is a challenge!"

KARE ANDERSON'S ACCOMPLISHMENT:
"Getting unlikely allies to see how they serve their mutual interest better by working together. This has happened three memorable times."

STEFAN SAGMEISTER'S ACCOMPLISHMENT:
"My very self-serving answer: Our book, *Sagmeister: Made You Look*, because it got us by far the most feedback of any project we've been involved in."

"RECOGNIZE AN HONEST DAY'S WORK AND GO HOME."

—ANDY STEFANOVICH

• • •

All work and no play makes Designer Jane a dull girl. Spending all your hours at the office and no hours actually experiencing the vibrancy of other activities will affect your ability to conceptualize and manage your workload. It will even affect your personal sense of balance and wellbeing. The human body simply loses its ability to work at high efficiency after too long on the job. That's why the amount you produce in two eight-hour days is always going to be higher in quality and quantity than work you produce in one sixteen-hour day.

"Creating balance in my life is the key to overcoming my creative blocks," says Dianne McKenzie of Comet Studios. "Taking short blocks of time off either getting away from the studio work environment, spending time in nature, galleries, or listening to live music all adds to the renewal process. We tend to work long hours and weekends, forgetting to take time to renew. We are very passionate about our work, enjoying the challenges of each project. Every time we make an effort to renew ourselves, we come back feeling refreshed, full of energy and creativity."

• • •

a Solution:
DON'T OVERWORK

Solution:
CHANGE YOUR SELF-TALK

a

Self-reliance and self-confidence are the tools that shape the innovation potential of your design business. And self-reliance and self-confidence come from only one place—your*self*. One way to build self-confidence is to choose to speak to yourself differently.

We all have the ability to change our negative self-evaluating thoughts—or "self-talk." For example, if our first impulse when confronted with a new challenge is to think negatively—"I'll never be able to get all of that done in time!"—then we simply must replace that thought with a positive one—"I'll really enjoy proving my abilities under such a tight deadline!" Michael Michalko offers similar advice in his book *Thinkertoys* with an activity he calls "Tick-Tock." The activity requires you to write out your negative thought or fear ("Tick") and then write an answer to that thought that focuses on the positive and starts to plot your course for success ("Tock").

We choose to be the person we are; we are the ones who decide our own lives. We choose how to speak to ourselves; we choose our own inner truth. If you decide to live your life positively, congratulating yourself on successes and relishing new challenges, then that is not a lie. That's who you are. You become more energized and confident by making that choice, and your work becomes more innovative.

> "CREATIVITY IS ALLOWING YOURSELF TO MAKE MISTAKES. ART IS KNOWING WHICH ONES TO KEEP."
> —SCOTT ADAM

Marcie Carson

• • •

When designers do not share their creative insight, they cheat themselves and the client. "Designers are frequently hesitant to speak honestly about a particular change or direction a project has taken," says Marcie Carson of IE Design. "Fearful of losing a client, designers often operate by the motto 'the client is always right.' But are they? Is this simply fear at work?" Carson challenges her fear by speaking up when a project takes an undesirable turn.

"Everyone has ideas," says Stephen Fritz of Olive, "but not everyone makes a conscious effort to overcome their fear of expressing and developing them." Make the choice to actively challenge your fear each time you feel a lack confidence or question your abilities.

• • •

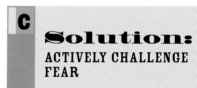

C Solution:
ACTIVELY CHALLENGE FEAR

Creative Challenge:
YOU LACK INSPIRATION AND STIMULATION

• • •

Often, it is easy to see which artist has influenced a designer's work. As members of an artistic community, we admire, emulate, acknowledge and tinker with the work of others. For example, the fresh, childlike flesh tones of 1800s French painter Adolphe-William Bouguereau can be seen in Mark Ryden's amazing illustrations. As creative professionals, we should all be constantly looking for inspiration and guidance in other artists' work.

The art world, of course, is a natural place for designers to seek inspiration. Fine art, cinematography, web animation, mosaic making, sculptures—even crafty arts like book making and rubber stamping—are common influences for a designer who needs an infusion of creative thinking. The truth, though, is that the entire world is open for visual shopping.

Kare Anderson, cofounder of the Say It Better Center, has several "visual shopping" methods. "I get in motion, sculling on the San Francisco Bay, visiting the Marin headlands, hearing someone talk about something completely new which can spark a new angle for me on the idea I am chewing on. Or I open up a book randomly to any page to see what I read and how it relates to what I am working on. Or I draw the runes—I'm Danish—and get the message."

Any aspect of life can be used as inspiration for any particular design project. The texture on a pair of boots one sees while walking to the office can find its way into a book cover design; a pile of litter next to a gated flower garden can inspire the color combinations to be used in a brochure project. Designers, as long as they keep their antennae up, can find useful imagination everywhere.

• • •

Jane Sayre Denny

• • •

Jane Sayre Denny of The Mad Hand art, graphics & design suggests finding inspiration by swapping artistic mediums for a time. "I'm a musician as well as a designer, and this method actually works best when substituting one instrument for another. For instance, what would normally be a vocal melody, try as a bass line. Or what you were going to play on the piano, play on a guitar. You get some of the most interesting things that way," she says. "But you can also do this with visual art. What you were asked to illustrate with pen and ink, try sculpting with putty or clay. Or what you were going to paint directly on the wall or canvas, design in Adobe Photoshop first.

"The point is not to actually use these creations against the instructions of the client (unless you've got complete creative license), but to jog the imagination to see what may happen by accident that you wouldn't otherwise see."

• • •

Concentrate on small details when a large project becomes overwhelming. Use one element or some tiny aspect of your design solution to find inspiration. "Step back inside the smaller areas of your idea that are working, and then work inside out," advises Gil Haslam of Novocom. "Often when you work in those smaller inspirational spaces, the bigger issues—the reasons for your creative block—will evaporate.

"If you can't see the forest for the trees, work on your favorite tree for a while. Sometimes it takes discovering a series of small breakthrough answers when trying to solve the big creative question."

A similar approach is to attempt to look at the world in a new way, focusing only on the small or solitary aspects of your surroundings. For example, look only for reds, or squares, or metallic surfaces. Forget the bigger environment and look for only what you need to be inspired.

Gil Haslam

Solution:
FORGET THE BIG PICTURE

a

NECESSARY SUPPLIES
Books, strips of paper, pencil, bowls.

. . .

ACTIVITY
Open books and pick out random words. Write individual words on little strips of paper. Place adjectives, verbs, nouns and phrases in separate bowls. Pick out words and use them to make a sentence. Use the unusual combinations to spark creative thinking and to practice making connections.

REALITY
Years ago I made annual calendars for Thomas & Kennedy (T&K), a local typographer. Working with the local creative community, I solicited artwork for the twelve different months.

For this one particular year I decided that the calendar would feature illustrations. I like illustrations because they have the potential to show a world that does not really exist.

I really wanted a connection between the client and the artwork. So I decided that the artists would be given a fantastic sentence to illustrate. Also, I wanted two nouns in the sentence to begin with *T* and *K*.

To come up with wonderful and bizarre sentences, I looked through books and picked out words that started with *T* and *K*; I chose nouns as well as verbs, adjectives and connector phrases. The different categories of words were placed in clean yogurt containers. Then I drew out words to make arbitrary and unusual sentences.

Some examples are:

- To their surprise, a fragile tepee insisted upon planting the thoroughbred knot because it was scratched.

- Meanwhile, a wild toad involuntarily dragged a broken kayak through the crowded streets while she slept.

- It happened once again on the wheels of a curving table that the potent kiss was quite possibly improved with age.

. . .

PATRICIA BELYEA,
Principal, Creative Director,
Belyea

a # Solution:
PRACTICE MAKING CONNECTIONS

• • •

Seeking out a kind of thinking contrary to your own can be an inspiring process. Steve Circeo at Maxcreative LLC likes to pick up a book on investing when he's stumped for an idea. "It doesn't matter what it is. The words play tricks that inspire creativity in the recesses of my mind." Other designers like to immerse themselves in something new by making simple changes to their day. One person might simply switch radio stations for the day or attend a reading by an unfamiliar author. Another person might eat a new, unpronounceable food, or exercise at a different time of day, or wear a cape or a flamboyant hat. Find small ways to introduce new activities into your days and see what inspiration or insight results.

• • •

Solution: a

DO SOMETHING
COMPLETELY NEW

When you need inspiration, seek out new sights, visit new places. (Photos courtesy of Brainfood Creative Programs.)

NUMBER OF PARTICIPANTS
A group of ten friends and clients.

NECESSARY SUPPLIES
A two-hundred-year-old, three-story villa in the Italian countryside, preferably near a winery, during the month of October.

• • •

ACTIVITY
After twenty years in the business I decided my batteries needed to be recharged in a big way. One night, at a dinner with a group of friends and clients, it was suggested that we all go to Italy. From an original group of sixteen, ten actually made the trip to stay in a nine-thousand-square-foot Italian villa for a month.

The group included a nurseryman with seventeen years of management experience, a computer specialist, a military person, a couple who owned a retail company, an owner of a family farm and dairy, a credit card company representative, a business consultant and a chef-in-training.

The travel adventure became a month-long brainstorming session and incubator for business concepts. Ideas, experiences, problems and solutions were shared on a daily basis. Wonderful wines, fantastic foods, incredible scenery and sensory overload at every turn added to the experience.

REALITY
The downside to such an adventure was not the expense in terms of out-of-pocket travel costs, as many would expect. We were able to rent the villa for the month at $500 per person, air fares were incredibly reasonable, and the value of the dollar was high.

My business, being a one-person operation, saw a dramatic impact from the trip. I spent a month prior to leaving baby-sitting clients, getting last-minute jobs completed and trying to schedule projects for my return.

When I seriously evaluated the cost of the trip, from a business point of view, being gone for one full month actually cost me three and a half to four months of income.

Would I do it again? In a minute. Today I have proven to myself I am able to work from wherever I may be at the time if I can find a decent Internet connection at a cybercafé to stay in touch with the outside world. Most of my business is done via the Internet anyway. I might as well be doing it from the Italian countryside with friends and clients.

• • •

JEFF FISHER,
Engineer of Creative Identity,
Jeff Fisher LogoMotives

C

Solution:
TAKE A MONTH OFF

"DON'T PLAY WHAT'S THERE, PLAY WHAT'S NOT THERE."

— MILES DAVIS

• • •

If you could live a thousand lifetimes, would you be a designer in each one? Probably not. You likely have other interests and passions, other realms you'd like to explore. But, in this life, you might also tend to forget about those other things you love for the sake of deadlines and new projects.

Ask yourself this question: What is your fantasy career? The job you would be doing if design weren't your first and foremost passion?

Solution:
REENVISION YOUR CAREER

a

Designer Peleg Top's fantasy career would be as a chef. "I love food and cooking. It is a great creative outlet for me. I love to improvise with food, present it and make people happy."

Instead of abandoning his love of cooking when the design jobs pile on, he's found a way to integrate both of his passions. "We actually are starting to have cooking classes at our new studio space for our clients. They all seem to want it so much!"

Career accomplishments can be wonderful and satisfying, but they are not the sum total of who you are. Don't forget to explore your other interests. "Remember that you are a human being working as a designer," says Randy Goad of Thunderwith Design. "Being a designer is just your job, not who you are or who you want other people to see you as. Just be true to yourself."

• • •

NECESSARY SUPPLIES
An Internet connection.

• • •

ACTIVITY
When I am absolutely stuck for ideas, I consult the Internet for random inspirations. Particularly using the Google (www.google.com) search engine, I click on the Images tab and type "logo" to see what I get. Also, sometimes using stream-of-consciousness words can bring some interesting results.

REALITY
I was asked to come up with an animated Web banner campaign for a series on Y2K preparation for medical offices. The text was provided by the copywriter: "Patient records, Inventory, Clients. How will your clinic handle the year 2000?" I needed a visual impact between the screens. Using my play-on-the-Web method, after some random words, I came across an image of Bugs Bunny. Just then, a light bulb went off. I recalled a cartoon where Bugs zapped someone with a magic wand or something, and poof, they turned to ash. After a bit of manipulation of the text, I did the same to the text in the first screen. The banner was a big hit, and I went on to create two more following the same theme.

• • •

C.D. REGAN,
Owner, Designer,
Maelstrom Graphics

a Solution:
PLAY ON THE WEB

NECESSARY SUPPLIES

Eyes, a brain, and the world around us. Also, a pencil or computer tablet, as doodling is a must.

• • •

ACTIVITY

The entire world around us is an infinite source of ideas. Its diversity is full of potentially new creations. One must be able to imagine variations or mutations of what one actually sees. For example, look at the world as if an image on canvas and try to reshape or recolor objects, as if malleable paint under your complete, godlike control. Yes, godlike! You can, and must, get carried away.

On another level, seek to intellectually decipher how a single object can convey a whole meaning or concept. Search for as many objects as you can that could possibly describe or symbolize a word or whole concept. Keep refining and honing until you obtain the best and most succinct result with the least images—preferably one.

REALITY

When designing the CD cover for Crowbar's *Time Heals Nothing* album, I was having no luck at creating something that really worked. Sometimes simplicity conveys a concept better than overworking or cluttering a screen or canvas. That night after realizing my comps were getting too complex, I was at home watching TV when I glanced over to see what time it was. Smack! The small face of my Roman numeral clock struck me like Big Ben. I immediately scanned it into my computer facedown. The stock photos of timepieces I was previously using were not the right style or shot at the appropriate angle. Sometimes you just need to view it a different way, or it requires a slight change of attributes, such as the face and numerals in this case. Now I had exactly what I needed. Coupled with an effective tombstone—an idea hatched after walking through a local graveyard a few days earlier—the combination of these two key symbols, with some digital effects, succinctly achieved my goal. The label and band agreed. Mission accomplished.

• • •

RICH DISILVIO,
President—Artist/New Media Developer, Digital Vista, Inc.

Solution:
GO ON A VISION QUEST

a

"THE CREATIVE INDIVIDUAL HAS THE CAPACITY TO FREE HIMSELF FROM THE WEB OF SOCIAL PRESSURES IN WHICH THE REST OF US ARE CAUGHT. HE IS CAPABLE OF QUESTIONING THE ASSUMPTIONS THAT THE REST OF US ACCEPT."

—JOHN W. GARDNER

• • •

RaShelle Westcott, a creativity coach and former graphic artist, tries to get her clients to look outside their current situation to find their inspiration. "When I first meet with someone and they're not experiencing themselves as creative as they'd like to be, I always ask them, 'Well, what's something outside of work that you love? That maybe you used to do but you don't do anymore?' I have one client who loves to draw. But he's in a big design firm and doesn't really get to draw anymore. So I asked him if he'd be willing to draw again and get back into what he loves about that creative expression."

Take a look at your past creative habits and recognize what you found nourishing about them. Try to integrate the better habits back into your routine, or find other activities that give you the same kind of creative nourishment.

• • •

a

Solution:
EVALUATE YOUR OLD CREATIVE HABITS

• • •

Between the monotony of press checks and client meetings and the high stress of idea generation, it's not surprising that designers, at some point in their career, hit a creative slump. It becomes easy to forget you're an inherently creative individual. But don't worry—sometimes all you need is a little reminder.

Reminders can be powerful tools when you're in a creative slump. It's often helpful to create physical, external cues that remind us of our innate creativity, courage and confidence in times when we feel defeated. In a cubicle or office environment, something as simple as creating a desktop "shrine" can be a great reminder. Anything that is personally meaningful, from a plant to a picture frame to a dog biscuit, can serve as a centering piece in a crazed business environment.

Mikey Richardson from Amoeba Corp. once used an external symbol to combat his fear. "I had a little image near my desk with a crossed-out shark on it. The shark represented my fear, my fear of diving right into the murky darkness of creativity and getting shred to pieces," he says. An image that's a tad violent, perhaps, but he used it "to recognize the fears, and try to ignore them."

Designers use external cues in different ways. Some, like Richardson, use it to acknowledge and dismiss their fears. Others project their fears onto an external object so that they can focus their internal resources on getting the job done. Some project their best qualities onto an external object to remind themselves why they are fully equipped to deal with anything thrown their way.

Experts often warn against using external sources to bolster internal resolve. For example, if you can only ever work up the courage to make presentations in meetings by playing salsa music for fifteen minutes beforehand, what are you going to do when a client drops by unannounced or the CEO pulls you into a meeting to ask your perspective on a company issue? It's dangerous to train yourself like Pavlov's dog, because what you're essentially telling yourself is that you can perform only when all external factors are in place. What's valuable is to create cues in your environment that remind you of your inner strength. Sometimes all you need to get you through a tough time is that comforting image, symbol, reminder that lets you know you've done well in the past and will do well again.

• • •

Creative Challenge:
YOU FORGET THAT YOU'RE A CREATIVE PERSON

• • •

How can you come up with stimulating ideas if your work environment is dull and boring? Designers use the world around them to inspire ideas, so make sure your little world gives you the kind of emotional lift you need to do great work. Don't go for a colorful and splashy décor if colorful and splashy isn't your thing; make your environment match your interests and comfort level, so that it can serve as your own creative cocoon. Designer Jane Sayre Denny shares her tips for creating the right environment:

• • •

CLEAN.
A clean environment is more conducive to creativity than a messy one.

PUT UGLY THINGS AWAY.
Leave out in the open only things you find attractive.

PLAY MUSIC.
The radio is preferable, so you're surprised.

LIGHT CANDLES.
Nothing empties the mind and funnels the attention like one small concentrated light.

a Solution:
MAKE YOUR PHYSICAL ENVIRONMENT INSPIRATIONAL

Clean, spare, with good use of lighting—the designers at Lodge show the effect of following Jane Denny's environmentally sound advice.

a

This nonmagic wand, designed by Artsiphartsi Gallery, was presented by the Women's Peacepower Foundation as a symbol of the ability to create change through one's own power. Make one for yourself and your studio mates to relieve some tension when times get tough.

• • •

What would you do if you had a real, functioning magic wand? How would you use it to make your work easier? Designer Peleg Top, for example, says that he would use a magic wand to add four hours to each day (including weekends, of course!).

We'd all like to have a real magic wand. Annoying vendor on the phone? *Zap*—the job is done right the first time. Client presentation that has you a little shaky? *Zap*—you're cool, calm and collected, and by the way, the job is yours. But you don't need a magical boost to make these things happen. You have the innate ability to create successful designs, win clients and collaborate with vendors—or else you wouldn't be in this business. Sometimes all you need is a reminder that you have those skills. And that's where a nonmagic wand can help.

The Women's Peacepower Foundation, a family-violence activism organization, has become known for their "nonmagic wands." "We hand them out at seminars, and people just love them," says Executive Director Diane McCabe. The wands were created as a playful way to remind activists that they don't need magic; they have the ability to create change through their own power.

Designers can also use this fun approach. When you have a scary client presentation ahead, give your head a tap to remind yourself that you have the strength to get through situations like this. When a deadline is approaching that's making you manic, take a few minutes to swish your wand over your work and relieve a little stress. (Make your wand durable; swishing can get pretty violent, depending on the deadline.)

• • •

Sheree Clark and John Sayles

Announce your creative events with the enthusiasm and banner-waving of a stadium gathering. The artists at Sayles Graphic Design like to conduct an opening ceremony for their brainstorming events. "Play a loud rock song or a sports movie theme," they recommend. Loud music can get brainstorm participants in the mood not just by elevating their energy levels, but by reminding them that they are part of something important—important enough to get its own theme song and opening ceremony!

• • •

g Solution:
HAVE AN OPENING CEREMONY

Lanny Sommese

Solution:
DON'T BE A STEREOTYPE

a

"You don't have to look creative to be creative," says designer and professor Lanny Sommese. "You don't have to have the beard, the long hair, the paint-splashed jeans, or speak 'Artfart': 'Ah man, I don't know, it just felt good to me.'"

Designers have to struggle enough against the perception of the "flaky artist" or the "aloof artist." You don't have to fit the stereotype to fit the community.

Randy Goad of Thunderwith Design says that artists should just relax and be themselves. "But for some designers that might be too difficult," he says wryly, "due to their holier-than-thou, dressed-in-black-with-that-leather-jacket, cell-phone-in-one-hand-and-coffee-in-the-other kind of attitude. You know who you are."

NECESSARY SUPPLIES
Black plastic garbage bag, matches, and a bucket of water.

• • •

ACTIVITY
Take a black plastic bag and tightly wind it while still keeping its length. Run the bag over a stove's open flame, carefully melting the circular folds together without melting the bag completely. Hang the bag in a dark, quiet room from the ceiling approximately five feet above a bucket of water. Ignite the end of the bag that's above the water.

When ignited, flames drip in an ever-increasing rhythm of light and intonation that sounds like a cross between an electronic bug zapper and a flame being extinguished in liquid.

A meditative and mesmerizing cadence ensues as the ignited end melts off and falls and is squelched by the water: an aural sculpture of mathematics, speed and gravity all in one.

REALITY
I was reminded of this event when brainstorming for a poster. I needed a secondary embellishment for the

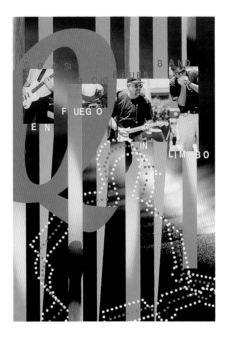

image and remembered the observed frequency of sound and light and of how it changed relative to my perception over time. This inspiration manifested itself in the form of a particular linear background pattern.

• • •

DAVID CONOVER,
Principal,
Conover

David Conover used his pyromaniac instincts to create the linear pattern in this poster.

Editor's Note: If you try this at home, please don't set fire to yourself or your surroundings in the process. Also remember that setting fire to plastic can result in some nasty toxic fumes.

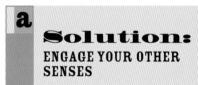

Solution:
ENGAGE YOUR OTHER SENSES

Brad Gaskill knows how to make his own fun.

Solution:
MAKE YOUR DESK A PLAYGROUND

NECESSARY SUPPLIES

Brad. Desk full of skateboard toys, a ball shaped like a gorilla, and an astronaut. If these items are unavailable, you may substitute another designer and the toys or objects of interest on their desk.

• • •

ACTIVITY

When Brad Gaskill of Artworks Design feels a little lacking in the creative department, he clears all important papers from his desk and turns off his monitor. He keeps the job tickets on his desk, as those can be transformed into a half pipe. He pops in a CD of his band Dead Planet and the next thing you know, the gorilla ball is bouncing off the wall, the astronaut is doing a Switch Smith Grind to a Benihana 720 to a Feeble Grind Dark Slide to a 1080 Hazard Revert.

REALITY

Brad was working on a Web site for a large corporation. They wanted to maintain a professional image, yet give a feel of fun and excitement. Otherwise, there were no specs for the job. Brad could go where Brad had never gone before. Where to start? Well, the astronaut appeared on the desk, the music was loud, and Rad Brad came up with one of the best Web sites he'd ever done. In fact, there are still blue marks on the wall where the gorilla ball hit one too many times.

• • •

KIM DRURY,
Senior Designer,
Artworks Design

Occasionally it's nice to interact with another living being who doesn't demand your constant creativity. Numerous studies tout the health benefits of having a pet, but for a designer, the biggest benefit may be that your loving feline or canine friend requires you only to be creative enough to open a can and slop its contents into a bowl. "My creativity advice? Hug your cat!" says designer Jane Sayre Denny. "There is nothing more inspirational than a furry buddy who loves you." A cat (or dog or ferret or rat or gerbil) has no unattainable demands or deadlines. A pet can be a great reminder that you can be loved regardless of your Photoshop skills.

• • •

Jane Sayre Denny's cat, Moby, is a welcome fixture at her home-based studio.

a Solution:
GET A CAT

Some people are verbal thinkers. They need to talk out their ideas in order to see them truly take shape. The bantering and discussion process can shape an idea into something it didn't have the potential to be when just one mind was contemplating it. Two minds, or three or eight or twelve, pursuing the same problem can present hundreds of possibilities for its solution. Even designers who don't naturally think out loud can benefit from this process, simply because their one idea has the potential to multiply into a rabbit patch of ideas once a group starts discussing it.

"What I like best about working ideas out verbally is that as I'm explaining them to others, I start to understand them myself," says designer Bruce Turkel.

Borrowing from other brains is a long-standing tradition in the ideation process. Why did Alex Osborn invent our modern concept of brainstorming if not to draw on the power of a group of brains to create something magnificent? When we look past our egos, the part of ourselves that doesn't want to share our brilliance or "borrow" from another's brilliance, then we can see the amazing potential of working together to generate ideas.

...

Creative Challenge:
YOU THINK BEST BY USING OTHER PEOPLE'S BRAINS

Jack Anderson

• • •

"I create and design through people and with people, as opposed to sitting alone and waiting for an epiphany," says Jack Anderson of Hornall Anderson Design Works, Inc. "I think more creatively through talking it out, like during a brainstorming session, and working through metaphors and rearticulating the problem. The way through a moment of creative block is to change how you look at the problem, not by sitting on hot rocks waiting for a vision to appear."

Unless you're working from a home studio, you have the benefit of being surrounded by other creative professionals on a daily basis. Use it to your advantage. Cultivate an environment in which designers can pull others from the office into their projects for a quick brainstorming discussion. Take advantage of the brains around you.

• • •

g. Solution:
CREATE THROUGH OTHERS

• • •

A quick way to get several perspectives on a design challenge you face is to tap into your local design resources. A simple e-mail to the right people can lead to a wealth of ideas and insights. "An important resource is the AIGA," says Jason Burton of Know Name Design, who frequents the American Institute of Graphic Arts web site at www.aiga.org. "If you take advantage of your membership, you can always send an e-mail out and get more resources than you can handle in return."

Also attend shows and lectures to cultivate a group of local designers that you can call upon in a time of need. Visit the forum at howdesign.com. Having buddies in the design business can only make your own work easier.

• • •

Solution:
USE LOCAL DESIGN RESOURCES

Jason Burton

"A MOMENT'S INSIGHT IS SOMETIMES WORTH A LIFE'S EXPERIENCE."

—OLIVER WENDELL HOLMES

NUMBER OF PARTICIPANTS
Any.

NECESSARY SUPPLIES
Provided by participants.

• • •

ACTIVITY
Ask each participant to bring an example of something they consider good design and bad design. Ideally the examples should be the same kinds of items you're trying to create—print ad, direct mail, etc. Share them with the group and describe the reasons you like or dislike them. Use the reasons to turn the conversation toward your client's product or service, and how the good or bad designs you've shared can be part of your own designs.

Alternate: Instead of bringing good and bad examples of specific component types, suggest bringing things that are relevant to your client's industry, like health care products or food packaging.

REALITY
At a recent staff retreat, we saw everything from party invitations to gift packaging to magazine ads to motorcycle brochures to a Michael Graves egg timer. The activity allowed us to open our minds and discuss the value and relevance of design as it related to our clients' needs.

• • •

JOHN SAYLES,
Creative Director/Partner, and
SHEREE CLARK,
Director of Client Service/
Managing Partner,
Sayles Graphic Design

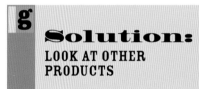

g: **Solution:**
LOOK AT OTHER PRODUCTS

loading...

a UBIQUITY LABORATORY production

Lisa Herter and Jared Jacob of Ubiquity Design, Inc.
express their chemistry with these Web illustrations.

Solution:
TALK IT OUT

g

NUMBER OF PARTICIPANTS
Whoever shares the same work space (within talking distance).

NECESSARY SUPPLIES
Inspiring background music and a different project.

•••

ACTIVITY
While you are working on another project (preferably mind-numbing production work), talk through your ideas. You should be among non-judgmental peers, so that you can throw out ideas you have been thinking about but have been reluctant to say. They don't have to be practical, feasible or appropriate. Someone starts with, "You know what would be cool?" The ideas could be fragments or phrases. They just have to get the ball rolling. Build off of one another's ideas. The point of this exercise is to open your mind to all the directions (possible or not). The essence of the ideas

can be boiled down, no matter how obtuse, until only the good parts remain.

REALITY
Jared, my business partner, and I are on opposite ends of the world, mentally and creatively, but somehow we have the chemistry to make our relationship work. Once, when we were trying to answer the question every designer asks—"Where do logos come from?"—as though there were a scientific formula.

Our visual answer is the "conception" section of our Web site. The series of colorful beakers and laboratory equipment represents the chemistry between designers and the creative process, both of which are anything but scientific.

•••

LISA HERTER,
Creative Director,
Ubiquity Design, Inc.

> **"RESULTS!
> WHY, MAN, I
> HAVE GOTTEN
> A LOT OF
> RESULTS.
> I KNOW
> SEVERAL
> THOUSAND
> THINGS THAT
> WON'T WORK."**
> —THOMAS EDISON

NUMBER OF PARTICIPANTS
Any.

NECESSARY SUPPLIES
Heads.

• • •

ACTIVITY
Asking "What don't you like?" is the best way to start a session with a client. After all, everyone is a critic. It's American. And if you use what the clients like or ask for, they pay better.

REALITY
I use straw dogs. Bad ideas. In meetings at times to stimulate that process, ask what they do not like. The *Jurassic Park* lettering got to be finished this way. The client liked it.

• • •

MIKE SALISBURY,
King,
Mike Salisbury llc

C

Solution:
LOOK AT BAD EXAMPLES

Editor's note: To jump-start your ideas (and to get a good laugh), visit the many online sites dedicated to gallery collections of bad art. A couple to get you started: the Museum of Bad Art at www.glyphs.com/moba and the Ohio Bad Art Guild at www.obag.org.

Solution:
PLAY DR. FRANKENSTEIN

g c

NUMBER OF PARTICIPANTS
Unlimited.

NECESSARY SUPPLIES
Old, broken toy parts. Maybe some tape or glue.

Yard sales are the key to success for this activity. Go yard-saling for plastic dolls, action figures, trucks and Matchbox cars, building blocks—all your standard childhood fare. Then savagely rip the arms off the dolls, the wheels off the trucks—be brutal. (This is the activity that brings out that wicked childhood impulse to set the cat's tail on fire. Just please don't involve any live animals in your actual brainstorm session.)

• • •

ACTIVITY
Dump the bag of mutilated children's toys onto your conference room table.

Ask your client or the group this question: "What does your project need to be successful?" Have them equate a need with a toy part, and see what the project looks like in toy form once all the needs are assembled.

For example, a client might say, "The project needs to have longevity," so you'll give the project "legs." But the project also needs flexibility, so you'll attach those legs to a Plastic Man torso. And so on. What you'll discover is that as the client or group surveys the pile of toys, they'll realize that their project can have many more interesting dimensions than they originally envisioned. They'll start to see the possibilities—and perhaps even be more open to your design suggestions.

REALITY
I thought of this activity when I was listening to a friend who used to work in the toy industry. To come up with ideas for their next toy, her fellow employees would take a few of their competitor's hottest-selling toys, chop them up and recombine them. They'd cart those hybrid toys off to proposal meetings, and as long as it was considered at least "20 percent different" from what was already on the market, it was a go.

In that environment, rearranging doll parts seemed to lead to an utter lack of creativity, but in your environment, that kind of play can spark new ideas.

• • •

CLARE WARMKE,
Acquisitions Editor,
HOW Design Books

• • •

Steffanie Lorig of Hornall Anderson Design Works, Inc., uses her graphic artist skills to tap into the creativity and ingenuity of children through her Art with Heart workshops. The activities that the children do can be adapted to your brainstorming sessions, or you could conduct a children's workshop yourself.

• • •

ART WITH HEART ACTIVITIES:

• Personal Logo: Talk about how logos represent a company and what they are supposed to communicate. Show examples. Have your group write down all the words that represent who they are and then start doodling symbols that represent each one of those traits, encouraging them to simplify and combine ideas.

• Wigged Out: Use Styrofoam wig heads as a blank canvas. Have each person use markers to decorate a "Me in the Future" self-portrait, focusing on the hair. Add wire, beads, glitter, string, or other materials.

• Abstract Emotions Painting: Think Jackson Pollock. Show the group the drip technique he used. Have the artists think of an emotion that they felt strongly recently. Have them pick colors that represent those feelings, and use the drip technique to create their own emotional paintings.

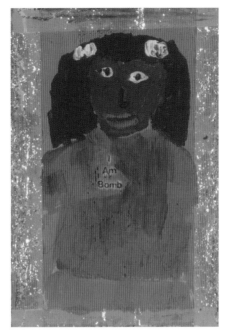

A child's artistic self-portrait

• Blessings Box: Provide each person a wooden box with a small slot on the top. Have them decorate it with things that represent what they are thankful for. The outside can be collaged; the inside could be just lined with velvet or pretty paper. Encourage them to write down good things on small pieces of paper throughout the week or month and store them inside the box. Whenever they are sad, they can open the box and be encouraged by the good things in their lives.

g Solution:
CONDUCT AN ART WORKSHOP FOR CHILDREN

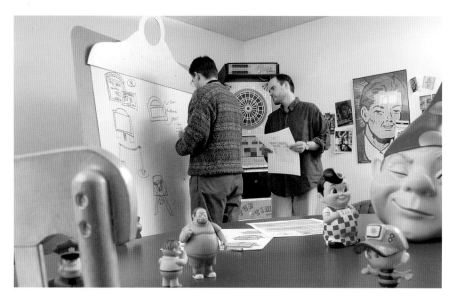

With all their fun stuff lying around, the designers at Thinking Cap Design can't help but create a casual environment. (Notice the larger-than-lap clipboard for collecting sketches and doodles!) Photo by Al Kolbeck.

Solution: CREATE A CASUAL ENVIRONMENT

C

NUMBER OF PARTICIPANTS
However many are in the meeting—no set quantity.

NECESSARY SUPPLIES
Pizza, pop and trinkets or toys of different shapes and sizes.

* * *

ACTIVITY
Create a casual, nonstructured atmosphere for your team and clients. Choose a more relaxed venue that will generate and encourage creative thinking.

REALITY
One such meeting included our design team gathering for a casual lunch meeting with a group from the client's side. When we arrived, we were greeted with a conference table filled with pizza, pop and an assortment of trinkets that the client had recently brought back from a trade show. A relaxed and playful interaction ensued. Soon, everyone was throwing trinkets across the table at each other. Not at all the typical business meeting, but ultimately as creative and effective in reaching a successful outcome. Allowing ourselves to relax and briefly "unfocus," we were able to generate creative ideas that ultimately led us to the solution we were seeking.

* * *

JACK ANDERSON,
Principal,
Hornall Anderson Design Works, Inc.

"MOST PEOPLE DIE BEFORE THEY ARE FULLY BORN. CREATIVENESS MEANS TO BE BORN BEFORE ONE DIES."

—Erich Fromm

• • •

If a problem still has you beat, regardless of how many brains have toyed with it, then it may be time to pull out the heavy hitters. "If you're stumped, call people with opinions you value," recommends designer Matthew C. Connar. "Call your mentors, old professors, friends or even your mother. Inspiration can come from anyone."

No matter how "seasoned" a designer you are, there's someone from whom you can learn. Seek out mentors and advisers, people who can lend an objective eye to your career and help you make important decisions. Most people of mentor status are there because someone helped them, and they're usually quite willing to give that good karma back to the universe. Make a list of a few people whom you'd like to have as guides on your career path, and give them a call. Invite them out to lunch. Propose a project you can work on together. Or just flat-out say, "I admire you and want you to be my mentor." You might be surprised by the positive responses you get.

• • •

a
Solution:
SEEK OUT MENTORS

Career
CHALLENGES

THE DESIGN INDUSTRY PRESENTS ITS PARTICULAR CHALLENGES FOR THE CREATIVE PEOPLE WHO POPULATE IT. A CAREER AS A GRAPHIC DESIGNER MEANS THAT YOU HAVE TO BE CREATIVE ON DEMAND. YOU ALSO HAVE TO SYNTHESIZE CLIENTS' NEEDS INTO A MARKETABLE IDEA, PRESENT THAT IDEA IN A CONVINCING AND PERSUASIVE MANNER, AND SOMEHOW MAKE IT ALL POSSIBLE UNDER A TIGHT TIME FRAME AND TIGHTER BUDGET. ADD TO THAT ALL THE OTHER TEDIOUS DETAILS OF RUNNING A BUSINESS—MANAGING THE ACCOUNTS, UPGRADING TECHNOLOGY, ARRANGING MEETINGS—AND IT'S NO SURPRISE THAT CREATIVE PEOPLE HIT CAREER SLUMPS. MOST OF THE CAREER CHALLENGES THAT DESIGNERS FACE OCCUR WHEN THEY BECOME DISCONNECTED FROM THE CREATIVE SIDE OF THEIR PROFESSION. IN THIS SECTION, LEARN TO COPE WITH THE "BUSINESS" SIDE OF BUSINESS, VALIDATE YOUR CREATIVE CAREER CHOICES, ADD CONFIDENCE TO YOUR PRESENTATIONS, AND FIND MULTIPLE SOLUTIONS TO EVERY DESIGN DILEMMA—ALL OF WHICH WILL HELP YOU CONCENTRATE LESS ON CAREER DETAILS AND MORE ON YOUR PASSION FOR DESIGN.

• • •

In your idea-a-minute workplace, you engage your right brain frequently. You create, you imagine, you visualize. But a significant part of your day must also be devoted to left-brain activities: keeping the books, working with computers, developing a marketing strategy. Admit it. As an artistically minded designer, playing accountant is not as appealing as brainstorming a new solution to your client's problem. But you must be adept at both to make your business successful.

Jeff Fisher of LogoMotives says, "The two biggest stumbling blocks to my creativity are the technical aspects of a computer-driven design business and the day-to-day fiscal requirements of running a business." Technology and money matters are top left-brain activities that designers must confront daily.

A very few design firms have chosen to integrate a full-time administration team into their staff. These administrators take care of the "business" end of business—setting budgets, answering phones, keeping records of accounts, arranging client meetings and so on. In this situation, designers are free to simply design. It can be a smart business move to arrange staff responsibilities in this way, letting the power organizers and power creators each work where their skills are strongest. Not every studio can be arranged this way, however, and it is up to the individual staff members to create the necessary balance.

The goal is always to find a balance between the business and artistic sides of the design industry, and often, that can happen only when a typically right-brained, artistic person chooses to flex their left-brain muscle. When your approach is balanced and knowledgeable, your business will be more adept and successful.

• • •

Creative Challenge:
YOU HATE THE "BUSINESS" SIDE OF BUSINESS

"Being creative to deadlines is a skill that all designers must develop and hone over time in order to, well, simply get the job done," says Alexander Lloyd of Lloyds Graphic Design & Communication. "It's more often than not a lot of sweat, frustration and downright effort that wins the day in most design solutions. Getting the job done on time, on budget and with a high degree of professionalism is what most design is really about."

As a one-man staff, Lloyd has become a pro at prioritizing. His tips for managing time well:

• • •

- Never put work in front of family.

- Give clients an idea of how long a job will realistically take, knowing urgent jobs will inevitably come.

- Don't promise something you can't deliver.

- Don't start late in the morning; it's time you can never recover.

- Group your work into three subgroups: jobs needed in the next one to three days, in the next one to two weeks, and within the next two to four weeks. Make sure you always go through each pile daily to make sure you're making headway.

- When someone says "Don't panic, there's no hurry," don't listen to them. That is the surest way to have a job sit on your desk for six months without being touched. And there's nothing more embarrassing than calling a client about "that job you gave me six months ago."

- Don't avoid the billing, work-completion, noncreative stuff. It's ghastly and we all hate it, but when it builds up, it can be a real headache.

- Be prepared to churn some work out to get the job done. Let's face it—not everything you design will be considered "Best in Show." Don't get depressed because you've had a week of pushing out non-award-winning work.

- Leave replying to e-mail until the very end of the day. Replying to every e-mail as it arrives is usually not necessary, and it does give you a little break at the end of the day.

- Try really hard not to work on weekends. Nine times out of ten, your clients will be enjoying two days off with their family. So should you.

a Solution:
MANAGE YOUR TIME

Alex Lloyd

Solution:
RESEARCH AND DAYDREAM SIMULTANEOUSLY

a

NECESSARY SUPPLIES

Internet connection, design magazines (architecture, print, industrial design, etc.), art books, roll of trace paper, markers, computer, graphics tablet, Adobe Photoshop.

• • •

ACTIVITY

Spending time looking at other people's projects in many design fields inspires ideas and stimulates the creative juices. After several hours of research, start sketching ideas, layouts, color schemes on paper. Rolls of trace paper make it easy to overlay ideas on top of each other. Keep sketching, without judging. This is a warm-up exercise and not intended to be a final step. Get up, take a break, walk around the city. Look at buildings, walls, clouds, water and nature. Take a nap if you feel sleepy. Sometimes a nap, even in the middle of the day, opens up the creative channel to an idea, as the subconscious becomes conscious. After a break, start sketching again. Move from working in trace to working digitally on the computer, drawing with a tablet. Use Photoshop to prototype ideas, color and layout. The designs in the early stages start to take form. Document all the designs. Out of this process evolves the work.

REALITY

I usually work on our own redesign of our Web site during the winter holidays, as this has tended to be a slower time for our studio in the past. During a redesign phase, I felt blocked and rushed to come up with a design theme for our Web site. I wanted a different look than the other Web design studios. I wanted to express creativity while emphasizing business strategy. I spent some time on the Internet looking at sites, spent time looking in the studio design magazines. I took a walk to a SoMa art museum and wandered through gallery exhibitions. Inspired with color and stimulated with design and form, I returned to the studio to work on some sketches, using trace and black mat board and drawing with oil chalks. The ideas evolved as I worked with the Wacom tablet in Corel Painter, creating the image for the front page of our Web site. Within a few days the redesign was complete.

• • •

DIANNE MCKENZIE,
Executive Producer, Web Architect, Comet Studios

NUMBER OF PARTICIPANTS
20—100

NECESSARY SUPPLIES
Pencil, pen and paper.

. . .

ACTIVITY
To conduct a creative survey, you must come up with at least five different ideas for the project you are working on. Group all variations together in a list with negative space to the side of each. Attach a blank sheet to the back of the list. Now give your survey to everybody with whom you come in contact. Have them put their initials next to their favorite idea. If the versions you present provoke any more ideas, have the subjects write their ideas on the blank sheet. Take your survey with you to lunch, to your vendors, or even leave it in the lobby with directions. The goal of this survey is to get opinions from as many types of people as possible. Once you are satisfied, analyze the survey and narrow down your options.

The creative survey is best utilized when dealing with color schemes, tag lines and logos.

REALITY
During the initial process of naming my company, I had all sorts of words running through my mind. With the help of a thesaurus, I made a list of over fifty names that I thought were interesting. I needed a name that not only was interesting, but would also tie directly into the full capabilities that my company would offer. So I created a list of the words, with a header at the top that read, "What word best represents what you expect from a company that provides a design service?" I also left a blank page at the back of the list for people to write their own words. I brought the list everywhere I went and had at least twenty-five people initial it. Along with the initials, I received about thirty new words on the blank page. Comparing the popular words with the new words, I was able to narrow my list to three names. Now I could begin conceptualizing which name would brand my company best and provide the most unique look.

. . .

MATTHEW C. CONNAR,
President,
Boost Creative Company

g² **Solution:**
CONDUCT A CREATIVE SURVEY

Matthew Connar used a creative survey to get ideas for naming his company, Boost Creative. The logo, shown here, is a stylized graphic of the boosters used on the back of rockets during NASA's early years.

Solution:
MAKE A "STEW" OF IDEAS

NECESSARY SUPPLIES

Paper, pens, visual resources. We keep a file of objects, words and visuals we like or that inspire us in addition to magazines, books and Web sites.

• • •

ACTIVITY

We call this "making stew." First, we sit down and prep all the ingredients. Then we mix them together and leave them in the pot to simmer and turn into something delicious. We start all projects by sitting down with the client, playing psychiatrist and gathering information (who is your audience, what are the objectives of this piece or campaign, tell me about your company, list five adjectives to describe what you want this piece or campaign to convey, etc.). We ask what clients like, don't like, who their competition is, etc., and take those facts to our internal creative session. We then start vocalizing ideas, throwing every idea into the pot, writing down everything. We'll pull out samples that strike us somehow. We look at the shapes of the words used, the meanings of the words (often pulling out the thesaurus) and put it all in a pile. We then pull out the images and ideas that grab us, and we talk through these ideas a bit. Then we walk away from the project for at least one day, giving it no more thought. Somehow that break is usually all we need to come up with the winning idea so that we can really, uh, sink our teeth into the project.

REALITY

We employ this method often when our brains are completely saturated with a project. Often it's best after stepping away for a while if you have the luxury of time. We find that the best ideas creep into our consciousness during that twenty-four-hour break when we're driving, showering or trying to sleep (when the brain is relaxed and the project is on the back burner).

• • •

CAROLYN MCHALE,
Principal, Senior Designer,
Boldface Design

Michele Keen and Carolyn McHale

> ## "THE VERY ESSENCE OF THE CREATIVE IS ITS NOVELTY, AND HENCE WE HAVE NO STANDARD BY WHICH TO JUDGE IT."
> —Carl R. Rogers

• • •

We develop habits and routines not just in our personal lives, but in our professional lives, as well. Shaking loose from that habit can revolutionize the way you think about the project at hand. Mark Sackett at Sackett Design Associates suggests approaching your next problem from a counterintuitive standpoint. If you are typically a verbal person, sketch out your thoughts, keeping your mouth shut and the visuals going. If you are typically a visual person, articulate your thoughts verbally or write them down. If you're naturally a writer, approach your problem with a sketchbook, using visual support for your ideas through research, clipping, tearsheets, etc.—anything to help you communicate your idea outside of your normal pattern. The challenge of approaching a problem in a way contrary to your nature will disrupt your usual, staid thinking patterns and lead to more interesting results.

• • •

a

Solution:
APPROACH A PROBLEM COUNTERINTUITIVELY

"GENIUS IS ONE PERCENT INSPIRATION AND NINETY-NINE PERCENT PERSPIRATION."

—Thomas EDISON

• • •

A designer said something interesting recently in a HOW magazine focus group: "We don't get paid for our learning curve." Designers live in a fast-paced world of project after project after project. The few moments a designer has free to flip through *Publish*, *Communication Arts*, *Print* or *I.D.* magazines can sometimes lead not to inspiration, but anxiety attacks. Look at all the skills I don't have, the anxious brain says. Look at the new software I'll never have time to learn. Look at the Web animation technique that I just know my client is going to see and ask for—and I have no idea how to do it.

Solution:
PAY YOURSELF FOR YOUR LEARNING CURVE

Clients aren't interested in paying designers to learn how to do their jobs. They want to pay them to do it, as quickly and cheaply as possible. A client isn't going to treat you to a JavaScript or Adobe Photoshop class. And the prospect of paying for such a class yourself—in time and money—is impossible to even contemplate with deadlines looming. Here's where we have to go back to that seemingly impossible rule of a creative's life: Productivity will rise when you take time away from the job to refresh and renew. As Henry David Thoreau said, "The truly efficient laborer will not crowd his day with work."

The answer is to pay yourself for your learning curve. Make a commitment to furthering your business by expanding your knowledge base. For example, budget for a technology class. Recognize that it is absolutely essential—and worth the money—to stay ahead of the competition. Learn the latest techniques in whatever computer program appeals to you most or is the most useful for your business.

Or budget for a fiscal class, and budgeting will forever be easier. Financial empowerment is personal empowerment. Knowing exactly where your money is and where it is going gives you a sense of security; knowing how to pick investments gives you a sense of adventure and confidence.

• • •

NECESSARY SUPPLIES
A dictionary.

ACTIVITY
Grab your trusty dictionary and simply thumb through for ideas.

REALITY
This activity sounds like something that is more in tune for a copywriter than a designer, but I think it works very well for a designer trying to come up with a fresh idea.

For instance, I just opened the dictionary and came across the word *oppidan*, a word that I have never heard of before. The definition is (1) of a town; urban; or (2) a person living in a town. Now this conjures up images of urban life, cities, New York's Times Square, big flashing billboards, giant moving images, Broadway signs, neon, etc. All of those ideas can be the starting point of a graphic solution.

The next word in the dictionary is *oppilate*, which means to block or obstruct (the pores, bowels, etc.). This obviously causes some mental images that can describe the creative process.

Now I can use the first two words on this page to help create visual imagery and stimulate the brainstorming process.

• • •

RANDY GUNTER,
Owner, Creative Director,
Gunter Advertising

Randy Gunter

a

Solution:
BRAINSTORM LIKE A COPYWRITER

Solution:
ASK BETTER QUESTIONS

C

• • •

Communicating with clients is one of the most difficult tasks designers face. Conversations between visual and nonvisual people can be as futile as conversations between a dog and a rock. But the blame doesn't lie entirely with the thickheaded client. Designers can be to blame, too.

Freelance designer Andrea Hatter says that she combats this problem by truly trying to understand her client's vision. "I ask as many questions as I can to get an idea of the look and feel that the client wants," she says. "I ask her history, where her name came from, what she sells, why she sells it, and how long she's been selling it. I even try to lead her toward similes. For instance, she might say, 'I want my business to look like Texas Instruments.' Then I have something to look at. I submerge myself in that design style so I can get into a similar mental state as the client. It's kind of like when an actor takes on the traits of a character so as to perform that role better."

Illustrator Steve Lawton says creatives shouldn't be timid in asking questions of their clients. "Many people seem to be afraid of asking questions in case it makes them seem unprofessional or stupid. The opposite is true. Find out everything you can about the job; ask for reference or style samples; find out if they have any specifics in mind. Research the subject as best as possible and don't fake it. And if you need to, call and ask more questions.

"The client will always be right," says Lawton, "but they are paying you for your experience as well as your talent."

• • •

> ## "ONE CANNOT CREATE AN ART THAT SPEAKS TO MEN WHEN ONE HAS NOTHING TO SAY."
> —André Malraux

• • •

In the 2001 edition of *Artist's and Graphic Designer's Market*, self-promotion expert Ilise Benun tells the story of Matt Pashkow, who decided to build his design business by targeting clients and companies rather than waiting for work to come to him. Pash resorted to "quasi-guerrilla marketing tactics" to lure clients to his newly established Digital Soup studio. He started by going to the liquor store and perusing the wine labels for design content rather than alcohol content. The vineyards in need of a fresh look were soon receiving promotional packages from Digital Soup. "By targeting companies who needed help, Digital Soup's initial vineyard mailing yielded a whopping 10 percent response," writes

Benun. "So Pash started targeting every Los Angeles restaurant with a subpar menu, and every Melrose boutique with poor signage, and every Hollywood production company with a tired logo. Before long, he couldn't walk five feet without bumping into someone who needed Digital Soup."

Benun advises taking the tactful approach to quasi-guerrilla marketing. "Approaching prospects you think need help requires diplomacy and tact. You can't just come out and say, 'This is really bad,' because they may not agree—and they may have done it themselves," she says. "It is also possible that they know it's not great but didn't have a choice but to go with it. What you can do is put the spotlight on how you could do it better, and maybe even point out the specific elements that you think don't work."

If you hate the business side of business, make your life easier (and more profitable) by picking your projects and pursuing only those clients. Your client relations will benefit from the beginning when you are offering to improve their business with your skills.

• • •

C
Solution:
GO TO THEM

• • •

Think about the chain of reactions you have when you accept a new design project. Your reactions probably follow a course something like this:

Exhilaration that someone has hired you ("I'm amazed every time the phone rings!") leads to ...

Industrious energy to get the project going ("This is going to be our best campaign ever!") leads to ...

Panic that the right idea will never come ("What was that deadline again?") leads to ...

Questioning why you ever took this damn job to begin with ("We should have known we had too much to deal with right now!") leads to ...

Insight and completion of the job ("Eureka! Yes, let's do it this way and get it done.").

Unfortunately, the panic and questioning stages can seem to last the longest. And the same panic and questioning

stages can occur on a larger scale, with your career. After years of arguing with clients and checking press runs, parts of your day can seem futile or redundant. It becomes harder and harder to remember those days in college when you had so many ideas that concentrating on one project seemed nearly impossible. It's hard to remember when you felt creative most of the time, and it's hard to remember why you chose a career that subjects you to this cycle of exhilaration, panic, and questioning.

The fundamental thing to remember in those moments of doubt is that, in your career, people pay you to create your vision. Your ideas are considered so valuable that they have a price tag. In those moments of doubt, go back to the basics, the fundamental reasons that made you choose a life as a designer. Take some time to really revel in the knowledge that only you can do your job as well as you can.

• • •

Creative Challenge:
YOU QUESTION WHY YOU EVER STARTED IN THIS INDUSTRY

● ● ●

Whether you come from a fine art background, a Web design background or a commercial art background, your roots as an artist probably began in a ragtag little notebook you carried around by the age of eight. You probably scribbled in the margins of your primary school notebooks, creating drawings that convinced the teacher you were off in your own little world instead of paying attention. You used your hands to make pictures at every opportunity. Art class was the place where you either excelled—if the instructor recognized your talent—or spent a frustrated hour in a battle of wills with a small-minded, color-in-the-lines art instructor.

Letting yourself draw and sketch is one of the simplest ways to tap into your original creative energy. It's the same compulsion you had when you were in an elementary school art class—draw something amazing, and that'll lead to something else amazing. The process is limitless.

When designer Andrew Epstein needs to tap into his creative energy, he doodles. "I draw thumbnails, sketch stuff, doodle around with a sexy fountain pen. I have a large pad of tracing paper and a pile of interesting music to get me started. Sometimes, I get on my bike and ride to Lake Michigan, find a park bench, relax, and see what flows out."

Spend some time each week doodling and drawing just for yourself, not for any project you're currently working on. You may find solutions to your work problems when you do this, but consider it a happy accident when it happens.

● ● ●

a Solution:
DRAW

This Moviegoer Magazine *spread is one of Andrew Epstein's many sketches that yielded successful results. Photo by Richard Corman of* Whittle Communications.

One of the quickest and easiest ways to rejuvenate your interest in the design industry is to look at the really fabulous designs that have been created in the past and now. Go to exhibits of work. Look at annual design collections from sources like *Communication Arts* magazine. Subscribe to design magazines; browse through design books at your local bookseller.

"Nothing is better than taking off your shoes, sitting in a blow-up chair and browsing through the latest design magazines," says Kim Drury of Artworks Design.

Also talk to your fellow designers. Talk about trends—what you like, what you don't, who's a hack, who's an innovator. Swap war stories about your hard times and your best payoffs. Share information about upcoming awards or competitions. Look for influence and energy amongst your professional peers, and you'll know why you started in this business—to be better than all of them!

Solution:
LOOK FOR INFLUENCES

Shannon Bailey of Know Name Design takes a few moments to flip through (product plug!) HOW Design's Creative Edge: Letterhead and Business Card Design, *by Lynn Haller.*

NUMBER OF PARTICIPANTS
4

NECESSARY SUPPLIES
Bookmaking supplies such as paper, pictures and binding materials.

• • •

ACTIVITY
To get them in touch with their creative roots, each Belyea designer was asked to make a 5" x 5" book. They were each given a topic that had to do with the Belyea design studio: People, Process, Ideas, and Work. The time frame to complete the project was one month. The designers were allowed to talk with one another about their projects, but not with the creative director. Each was to be a personal response to the project.

REALITY
One weekend I went to a unique music store that had framed pictures of the staff on the wall with little personal stories. I mentioned in our Monday morning meeting that Belyea could do a version of this "wall of fame." My staff was polite enough not to say that they hated the idea, but instead came up with another suggestion. It was to develop a little book that included information about all the Belyea people for our reception area. As everyone wanted to produce this book, we instantly came up with the idea of creating a series of Belyea Little Books.

The big deal about this project was that I, the creative director, would not see any of the books until they were finished. We planned to meet for a special Friday afternoon get-together at the end of four weeks.

All the books were tremendously different. The book on Ideas was bound in string and had textures from East India—inspired by that designer's recent trip to Asia. The Process book stretched out as a Z-fold document with the process steps on one side and quotes by famous folks with provocative photos on the other. The staff photos in the People book were faces smashed in the scanning machine; the page layouts were done with pasted-together type that had been photocopied many times. The last book, on Work, had petite pockets with petite portfolio pages.

• • •

PATRICIA BELYEA,
Principal, Creative Director,
Belyea

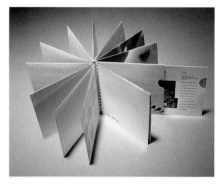

This book, designed by Kelli Lewis, is a "petite portfolio" for Belyea.

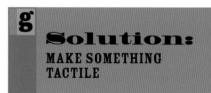

g **Solution:**
MAKE SOMETHING TACTILE

"TO INVENT YOU NEED A GOOD IMAGINATION AND A PILE OF JUNK."

—THOMAS EDISON

It may not be a dank and cluttered basement, but this is where Mikey Richardson indulges his "crackpot inventor" impulses.

Solution:
CALL YOURSELF AN INVENTOR

a

• • •

Mickey Richardson at Amoeba Corp. defines creativity as "invention." He says that creativity is all about making new things. And it's true. Each day, you spend your time coming up with new products and new ways of making old products. The word inventor conjures an image of a wild-haired old man in his basement, tinkering with the crackpot invention that just might work. Relish your role as an inventor. Don't be intimidated by stepping into the ranks of the infinitely quotable Thomas Edison or the revolutionary Henry Ford. Inventors and innovators like Edison and Ford are still known today because they chose a path different from the one everyone else was following, and improved our lives because of it. They listened to their own inner voice, not the voice of their customers or clients. As automobile inventor Ford once said, "If I'd asked my customers what they wanted, they'd have said a faster horse!"

Boldly step into the ranks of these innovative inventors, and relish the mad scientist within.

• • •

NECESSARY SUPPLIES

Good local art course offerings, scheduled time, and desire.

• • •

ACTIVITY

Art has been a passion of mine since grade school. Taking art classes, or working on art projects unrelated to my graphic design business, has always helped me challenge myself and maintain a high level of creativity. When I was at a low point in my career, stuck in an unpleasant corporate-like job, the printmaking classes I took resulted in my work being sold in several galleries — and my art work being used as set decoration on the television soap *Days of Our Lives*! This experience made me realize I didn't want to be part of a sterile, corporate-like setting.

I prefer to work independently. In fact, the mantra for my business has become: "It's not that I don't play well with others; it's just that I want to choose where, when and with whom I play." The variety and challenge of new clients, and new projects, helps me maintain a high level of creativity. The freedom allows me to travel, read, take courses, write, visit museums and galleries, garden or any number of other activities. All recharge and release my creative energies.

REALITY

It is often difficult to remain creative in structured job situations where you get into a project rut or are required to take on responsibilities other than design. Years ago, when I had real jobs, I would find myself getting very bored with the repetitive nature of some of the projects or efforts for particular clients. I designed and produced a series of medical publications for a client on a contract basis for a couple of years, prior to being brought on staff as the art director. In a very short period of time I found myself going through the motions of a job a chimpanzee could be trained to do. In addition, management responsibilities were of little interest to me and I had little choice in the matter. What helped me maintain some degree of sanity was to take some art classes unrelated to graphic design or my work.

• • •

JEFF FISHER,
Engineer of Creative Identity,
Jeff Fisher LogoMotives

a Solution:
TAKE A LOCAL ART CLASS

NUMBER OF PARTICIPANTS
2–10

NECESSARY SUPPLIES
Large, thick, brightly colored papers cover the entire length of a medium-size hallway in our office. Dispersed on the tables are art supplies such as paints, markers, tape, letter-size pieces of colored paper, magazine clippings, paper towels, etc.

ACTIVITY
Some sort of music is always on quietly to get people motivated to think. Dialogue begins and as time progresses, the brainstorming moves to the large pieces of colored paper hung on the walls. The papers will evolve into a collaborative collage between the clients and the artists/designers. As ideas in the form of imagery and words surface, they are added to the collage. At the end of the session, there is a wall full of expressive and interesting ideas that can then be redirected or focused. But it gives us a solid ground to start from that isn't the "usual." It lets the clients feel like they have an active role, and they begin to really enjoy themselves on a creative level. This can take anywhere from twenty minutes to two hours.

• • •

MICHELLE HINEBROOK,
Illustrator;
HANNAH FISHMAN,
Graphic Designer,
StudioFEM

Hannah Fishman and Michelle Hinebrook

Solution:
COLLABORATE ON AN IMAGINATIVE PROJECT

C

NUMBER OF PARTICIPANTS
1–5

NECESSARY SUPPLIES
Paper, pen or pencil, magazine(s).

• • •

ACTIVITY
This activity can be done with yourself or with a few of your friends. Take a magazine or two and pull out three to five pictures. Turn all of the images upside down. Pick one of them and flip it over. Within ten to fifteen minutes, write down as much as you can about that picture; start a story with it. When the time is up, flip over the next picture. Continue the story, but find a way to incorporate that image into it. Repeat this process until you reach your last image and your story's conclusion.

Take the image(s) that your story places in your head, and incorporate it into an art piece.

REALITY
Not too long ago in an English class, we were tasked with creative writing. We had only the class period to finish the story, and I, like my classmates, was stumped on what to write. I had a magazine on my desk so I flipped through and wrote about the first three pictures I came across, incorporating them into my story. I timed myself so I would finish by the end of class. It turned out to be a great project.

• • •

DAVID PEARCE,
Pearce Designs

a
g **Solution:**
BECOME A STORYTELLER

• • •

No client will give you her business if you aren't able to effectively pitch your ideas. Persuasion is an art form, and one essential to the design business. Bringing others around to your point of view requires a skillful, trust-building approach, a projection of confidence and a loud, unwavering voice. Remember that beautiful poster design by type legend Herb Lubalin that read, "A diplomat is a person who can tell you to go to hell in such a way that you actually look forward to the trip (Caskie Stinnett)"? The art of persuasion can be seen in those words.

Creative Challenge:
YOU HAVE A HARD TIME PITCHING YOUR IDEAS

"The ability to persuade a client to see things the way a designer does is critical," says designer Bruce Turkel, who often speaks on the importance of presentation skills. "Because designers are visionaries and tend to see things before their clients—that's what we're paid for, by the way—you will often find yourself presenting ideas and visuals that are beyond the client's frame of reference. That's when it pays to be able to persuade."

Before you can work collaboratively in a relationship with a client, you have to establish your worth. If the client views you as a simple service provider and doesn't recognize you for your artistic vision and skill, then the relationship starts on unequal footing. And the client won't be convinced if you can't speak and present with conviction.

"Accept the fact that presenting is the most important thing you do," advises Turkel. "After all, if you can't present your ideas, then it doesn't matter how good they are. No one else will get to see them because the client won't buy them. If you're intimidated by presenting, go out and learn how to do it. I was terrified to speak in public and to present to clients—and that's why I started studying and practicing."

• • •

"CREATIVITY MAKES A LEAP THEN LOOKS TO SEE WHERE IT IS."

—Mason Cooley

C Solution:
BE KNOWN AS AN IDEA PERSON

• • •

Frequently in her job as a creativity coach for designers, RaShelle Westcott hears the words, "I want to be known as an idea person." Her clients look to her for ways to become recognized as a capable and creative person.

"I hear this plea a lot," says Westcott. "What I suggest is that my client simply proclaim, 'I am an idea person!' Market yourself as an idea person versus only highlighting the work you do. Many creatives talk about their work—the end product—rather than about how they came up with the idea. It's the idea behind it all that makes their final product so successful, and you need to exploit that."

• • •

Solution:

EARN RESPECT FOR YOUR BUSINESS PRACTICES

○ ○ ○

Run a respectable business, and clients will turn to you again and again. Ilise Benun, promotion expert, shares six tips for running a smart operation:

BE ASSERTIVE.
Don't wait for the phone to ring. Actively pursue the clients and projects you want. Introduce yourself to these prospects, show them you've taken time to think about their needs, then offer your perspective on their marketing materials, Web site, anything you can see.

BE CURIOUS.
Ask all the questions you can think of, and then some. Find out all you can about their needs, their market, their prior efforts and the results of those efforts. Not only will you learn a lot, but your curiosity will demonstrate that you're not a prima donna. The priority is their problem, not your design.

BE GENEROUS.
Offer your ideas freely. Do as much as you can without giving away the store, but enough to show how your mind works.

BE PERSISTENT.
It may feel pushy to keep calling even when they don't return your calls, but call again anyway. You are building a relationship, even when it feels like a one-way street. In the end, they will appreciate your persistence, and it will increase the odds that when they find themselves in their moment of need for your services, you will be familiar and the relationship will already have a solid foundation.

BE PERSONAL.
Tailor all your materials and correspondence—letters, phone messages, e-mail messages and portfolio presentations—to each client, so that it doesn't appear generic. Show that you took the time to integrate what you know about them.

BE COMPATIBLE.
When they say no, don't end the conversation there. If you are in the running for a project and don't get it, engage your prospect in a follow-up conversation about the choice they made. Learn what you can about their process and priorities, and use that information to build on the relationship for the future.

○ ○ ○

• • •

The biggest stumbling block in client relationships is the communication. Visual and nonvisual people are worlds apart when it comes to communicating concepts. But the value of getting a client's input—and really understanding it—is immeasurable. In fact, some designers say that the only true hindrance to their creative process on a project is not understanding the client's goals. "With insufficient information, a designer can wander around in the desert forever," says designer Burkey Belser. "While rain may fall and flowers may bloom, the bloom will never be the right flower without the right information."

Communicating clearly means paying a little bit more attention to how you phrase your questions. Typically, the more specific you can be, the better. It's the difference between what creativity writer Charles Clark calls a "steam-shovel question" and a "spade question." He describes a steam-shovel question as one that is so broad and vague that it will likely generate too many unusable and vague results. A spade question, on the other hand, is described as one "that really digs into the problem." When you're speaking with clients, instead of asking a broad question like, "What do you want to see this Web site design do for your company?" you can instead ask, "How can we improve your site's appeal among the Latino market by restructuring the navigational system?" Steam-shovel questions are generally valuable only at the very beginning of a project, when the project may be so undefined that some initial, general brainstorming is necessary to later focus the problem.

• • •

C Solution:
LEARN TO COMMUNICATE CLEARLY

A creative meeting in a conference room is sectioned off from an adjoining conference room by a garage door. When the door is opened, the rooms can accommodate all forty Greenfield/Belser employees, or a group of designers and clients who need space to communicate.

• • •

To be a successful designer, you must know how to sell yourself. Many designers could learn a few tricks from professional marketing execs.

"Marketers automatically put themselves into the shoes of their prospects, and then speak from that point of view," says promotion expert Ilise Benun. "So, for example, when presenting samples from their portfolio, marketers don't talk about why they chose the colors. Instead they talk strategically about how the piece solved the problem presented by their client."

Group presentations are often the highest stress circumstances for a designer reluctant to switch from artist to marketer. Kare Anderson, who coaches designers and other professionals on becoming an unforgettable public "face" for their organization, says the key to presenting is to find common ground and needs. "Instead of being self-conscious, focus on the part of each person that you most respect and how your presentation can serve the best talent and temperament of the people in the group. Speak of their needs and interests rather than your design. Focus on two-way flow, not trying to get them to like you or your design. Then people will feel heard and participatory."

• • •

Solution:
THINK LIKE A MARKETER

g

"ONE OF THE GREATEST PAINS TO HUMAN NATURE IS THE PAIN OF A NEW IDEA."
—Walter Bagehot

••••

"Creativity is the confidence to know that you'll get there, even though you are missing the roadmap and the road and the car and the fuel," says Leigh White of p11creative. That kind of confidence comes from knowing that your ideas are good and worthy of being presented to the world. White's tips for believing in your ingenuity:

OWN THE ROAD.

Maybe you'll be given lots of background information on a project. Oftentimes, you won't. Maybe you'll be paired up or put on a creative team. A lot of times, you'll be the only one behind the wheel (even when you are paired up or on a creative team). Be equally prepared to drive the project either way.

PEDAL TO THE METAL.

You must suspend your own disbelief. Go beyond your usual limits. The world will critique your work soon enough without you critiquing it for them. Allow yourself to fully stretch your brain for ideas. By the time your client has input, and the client's team has input and your creative director has input, and their dog has input, the idea will get chipped away bit by bit. It's much better to think "out there" and work your way in, than starting small and eventually becoming invisible.

ENJOY THE DETOURS.

Maybe the big idea will manifest itself with the first idea, or it will surface on the hundredth try. The path can change and often does from project to project. Be open to the intellectual stepping-stones you may encounter along the way. The point is to keep going until you find it. Your internal compass will get you there.

DON'T FALL ASLEEP AT THE WHEEL.

Take ownership right from the beginning. Think of a project as a chance to learn something new about an industry or product you never knew before. Try to personalize it so it becomes interesting to you. Be curious no matter how outwardly boring something may seem. Indifference will kill ideas immediately.

"HONEST, OFFICER. I WASN'T SPEEDING!"

The bottom line: You have to have faith in your stuff, and ability to bullshit. If you don't have conviction or belief in what you're saying, no one else will.

 •••

Leigh White

a **Solution:**
BELIEVE IN YOUR INGENUITY

Solution:
THINK STRATEGICALLY

C

"Design has really turned into a strategy business," says creative coach RaShelle Westcott. "It's creativity meeting strategy. I think designers are naturally strategic thinkers, but now are becoming known for it and are learning more about how strategies for business can work cooperatively with the creative process."

Westcott says that a strategy is really a "direction, philosophy, set of values, or methodology for building and managing specific objectives. Strategies establish guidelines and boundaries that keep you on track and moving toward the objective."

Employing this kind of forward thinking in your overall business practices and in your individual projects gives a high level of organization to your efforts. When you're organized, you can focus more time on finding creative solutions and less time on bookkeeping and project management.

It's also important to remember that you and your client are business partners, each of you with defined roles, obligations and responsibilities. Westcott recommends beginning a collaboration with a client by setting boundaries. Put what's expected of you and what's expected of them into contract form, and abide by it. It may seems strange, but putting guidelines and "rules" down in contract form can actually lead to more creative time and freedom later on, since no time is wasted in petty squabbles or redundant efforts.

As Westcott says, "When a business mind can come together with a creative mind, I think there's something brilliant that happens there."

• • •

NUMBER OF PARTICIPANTS

Designer and client(s).

NECESSARY SUPPLIES

A client with the need for an identity, and an Internet connection.

• • •

ACTIVITY

The majority—about 90 percent—of my business interaction now involves dealing with clients via e-mail, seldom talking with them on the phone and never meeting them in person.

To help me with the process of designing logos for such clients, I have created my Identity Client Survey. This document, sent via e-mail or snail mail, really helps the client to give additional thoughts to their identity needs. It is essentially a brainstorming tool to help drive the design process. The survey itself is an always evolving document, as I find better wording to get the answers I need from the client—or simply add new questions to help the process run more smoothly.

REALITY

Doing business as an identity designer exclusively via the Internet, does have some disadvantages. There are days when I have a rather hostile answer to the question "Isn't technology wonderful?" There must be a law that computer problems increase in magnitude exponentially with the increased immediate need of any given client. Either that or,

as I get more stressed out about a project deadline, my body gives off negative electrical pulses that inform my computer system it is time to make my life a living hell. Thankfully, most clients are accepting of technical glitches, due to their own personal experience with computers.

E-mail is not always reliable. I had one client "fire" me via e-mail because I had not responded to her previous cyber-missive. The message in question had never arrived in my inbox; she had not followed up to ensure I had received the e-mail; and I had not contacted her to see if decisions had been made, as some clients will take up to a week or more to respond with feedback. The client must have been even less pleased when I pointed out these facts to her in subsequent e-mail and voice-mail messages. I didn't even receive the courtesy of a response. The project was obviously beyond salvaging.

At times it is difficult for the client to put what are basically emotional reactions to specific designs into the cold, hard text of an e-mail. When phone conversations are not possible, an e-mail question-and-answer series works to fine-tune the client feedback about particular issues.

• • •

JEFF FISHER,
Engineer of Creative Identity,
Jeff Fisher LogoMotives

C Solution:
SHARPEN YOUR ONLINE
CLIENT RELATIONSHIP
SKILLS

NECESSARY SUPPLIES

A deck, cold beverages, a nice day.

• • •

ACTIVITY

To get the creative juices flowing, it sometimes works well not to worry too much about who the client is and concentrate more on outrageous, brilliant, creative fun.

REALITY

We had a brainstorming session on my brother Rob's deck one evening, knocking down a few cold beverages, when we talked about billboard ideas that never saw the light of day. One had a picture of cracked-open peanuts with a headline that read, "Everything for baseball nuts." As we were talking about it, the idea came to exchange the salted-peanuts graphic with a baseball protective cup. I think we laughed for ten minutes straight. Our faces were a deep red, and I was afraid some blood vessels would burst.

Of course, now that we had this brilliant idea, we needed a client. We contacted Kunkels Sports Center in Davenport, Iowa, and they loved the idea. We did print ads and had large posters printed for in the store. Customers kept requesting copies of the big posters that they had hanging in the store, so we made 11" x 14" versions to hand out that ended up in bars and basements all around the area.

• • •

RANDY GUNTER,
Owner, Creative Director,
Gunter Advertising

Solution:
FIND AN IDEA FIRST, THEN THE CLIENT

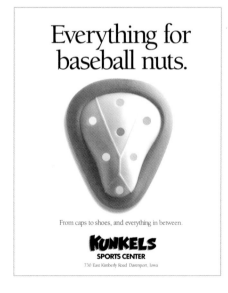

Everything for baseball nuts.

From caps to shoes, and everything in between.

KUNKELS
SPORTS CENTER
730 East Kimberly Road Davenport, Iowa

• • •

Oftentimes in a gathering of creatives and clients, the group might as well be honest and draw a chalk line down the center of the conference room table: "You're over there, we're over here, and never shall either side cross over." The discussion deteriorates into a my-view/your-view debate with neither side really listening to the insights of the other.

"When a group gets together, be more interested in absorbing the vibe than competing with the other brainstormers. And listen to the client," emphasizes Jane Sayre Denny of The Mad Hand art, graphics & design. Spend more time with your mouth shut than open. The goal of these discussions is to fill your brain, not empty it.

• • •

C

Solution:
LISTEN WELL

To improve the listening environment, it's often helpful to create a low-key brainstorming corner for designers and clients. At p11creative, it's the mezzanine—so comfortable that designers sometimes power nap up there!

Solution:
TRUST YOUR GUT

a

• • •

When preparing students for a standardized test, instructors always advise against second-guessing answers. More often than not, our first impulse is correct, and we risk losing points by deliberating with ourselves over our first chosen answer. You will be most persuasive when your audience understands that you have a conviction and belief in your ability to do things right the first time. Clients will learn to trust you in the way you trust yourself. As designer Andrew J. Epstein says, "If I try to be creative, rather than just accepting that I'm creative, I fail. The worse thing is not trusting my gut-level reaction right away."

• • •

"IT IS BETTER TO FAIL IN ORIGINALITY THAN TO SUCCEED IN IMITATION."
—Herman Melville

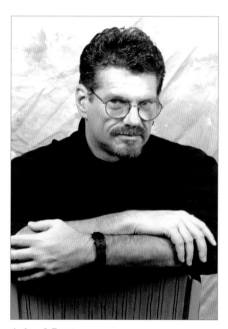

Andrew J. Epstein

• • •

As beastly as clients and prospective clients may seem some-
times, they're actually people, too. They have bad days like you,
so they deserve a little forgiveness. "Never forget the other
person is a person," recommends Steve Lawton of Air Hero's
Studio. "This is the cornerstone of relationship marketing."
Lawton has built his illustration business on long-standing
client relationships. Along the way, he's learned these rules for
making client relationships more beauty than beast:

DON'T TAKE ANYTHING TO HEART.
If they are busy and ask you to call back in a few days, don't
take it personally. Call them back in a few days!

GIVE YOUR WORK THE PERSONAL TOUCH.
Make sure you become a personality to a long-distance client,
and not just a voice on the phone. Make talking to you a pleas-
ant experience for them, and show an interest in them beyond
work and money. Refer to previous conversations. If they talk
about golf, mention golf, or if they talk about their kids playing
soccer, ask about the kids' games.

BE CONSCIENTIOUS.
Make sure you do what you tell them you'll do. If they say to call
back, do it. If they want additional images e-mailed, do it.

LISTEN!
The person giving you the job already has an idea in mind as to
what they want. The more you comprehend about a project, the
better your chance of knocking them out of their socks.

SAY THANK YOU.
Thank the client for the assignment. Deliver it early if possible
and make sure it has your name and phone number on it. Do a
follow-up to make sure everything was all right. Appreciate
their business, and they'll appreciate you.

• • •

C Solution:
**REMEMBER THAT YOUR
CLIENT IS ACTUALLY
HUMAN**

• • •

Without exploring the full parameters and possibilities of a project, you can't know that you've hit upon the best solution. Sometimes, yes, that first idea—that initial burst of insight and intuition—is the idea that best suits the project at hand. But even that idea must be explored in full: How can you make it better? How can you implement it in the best way possible?

The more concepts and ideas you spin out, the more possibility you have for finding the exact right solution for current and future projects. Unfortunately, clients and other outside forces often seem a hindrance to ideas, not a help.

Designers are in a constant battle to get their truly good ideas into the marketplace. Clients, politics and cautious marketing executives can get in the way of a good idea. This is the reality of the design business, but you can increase your chances of seeing your design visions realized if you have loads of ideas to implement. "Half or more of all good ideas probably never see the light of day. And then you start adding the ones that actually do get presented, and you put that through the creative, marketing and branding processes, as well as the political process, and these ideas get whittled down, homogenized and compromised. So a lot of times, the best ideas never do really make it, which makes it even more important that you generate not just more thinking, but more unique ideas," says designer Mark Sackett.

Some designers integrate this multiple-idea approach into their usual creative process. Steffanie Lorig at Hornall Anderson Design Works, Inc., refuses to edit herself in the ideation phase of her projects.

"In a class I took at the School of Visual Concepts here in Seattle, my logo instructor, Ken Shafer, taught me that it was in volume of ideas that you will find the solution," she says. "He encouraged us to do pages and pages and pages of exploratory sketches. He always said he graded by weight."

• • •

Creative Challenge:
YOU LIMIT YOUR DESIGN SOLUTIONS

A gathering of the minds at Gunter Advertising

Solution:
SHAKE UP THE USUAL MIX OF PEOPLE

NECESSARY SUPPLIES

Extremely large piece of brown paper, lots of pens, conference room

ACTIVITY

To get lots of good ideas, don't let anyone get too comfortable. In this activity, we spread the paper over the entire table and give everyone writing instruments to sketch and write notes on their section of the paper. Partway through the meeting, we yell "Switch!" and have all the participants swap places at the table.

REALITY

At one successful session, ten people had to switch places. The people on one side of the table crossed over to the other, and we ended up sitting next to different folks. This changed the dynamic of the room. Not only did we have new conversations, we had another person's notes in front of us. This allowed for new inspirations, new ideas—and for some people to be teased about their drawing ability.

• • •

BENNETT SYVERSON,
Associate Creative Director,
Gunter Advertising

Solution: DON'T THINK

a g

NUMBER OF PARTICIPANTS
No limit.

NECESSARY SUPPLIES
If you're alone, a pad and pencil is a good idea. (I guess that if the creative block is chronic or has been extended over a long period of time, any craggy chunk of charcoal and a blank wall in the office will do.) If it's a group, everyone should have paper and pencil or if you want to jazz up the process and expand the entertainment factor, a tape recorder is strongly recommended.

• • •

ACTIVITY
If I'm alone, I simply take a pencil and paper and jot down the first word that comes to mind pertaining to a project I'm stumbling over. Then, I proceed to record on the paper the very next word that pops into my mind. That is followed, as fast as possible, by the next word that pops up, then the next, then the next and the next and the next and so on. No thinking allowed. And no cheating. Each word on the list must be the first one that comes to mind as a knee-jerk reaction to the word preceding it, no matter how odd or off-the-wall it may be. The idea is to get to the point where the words come automatically, flowing as a stream, controlled only by the time it takes to get them down on paper, the faster the better (a tape recorder can speed things up a lot).

Obviously, the list could go on forever. My lists usually fall between 90 and 120 words. The signal that the end is at hand is when particular words start popping up for the third or fourth time.

If everything has gone correctly, the automatic nature of the process has enticed my subconscious into entering the fray. From deep within me my creative juices gurgle and bubble up through the idiosyncrasies of my client's problem and pop to the surface as words on my list. They often appear odd or weird and seem out of place on the list. They should, because they were spawned outside my normal creative channel. My job is to figure out why they're there and how they relate. More often than not, I find that these words are key to finding a creative reply to the problem at hand.

• • •

LANNY SOMMESE,
Professor and Head of Graphic Design,
Penn State University;
Principal,
Sommese Design

> # "IN CREATING, THE ONLY HARD THING'S TO BEGIN; A GRASS BLADE'S NO EASIER TO MAKE THAN AN OAK."
>
> —James Russell Lowell

NUMBER OF PARTICIPANTS
Unlimited.

NECESSARY SUPPLIES
Magazines, teams, team captains.

• • •

ACTIVITY
Divide meeting attendees into about four smaller teams to add a degree of competitiveness, making sure that teams consist of a variety of individuals. Corporate heads should be in different groups than their employees to limit potential intimidation factors and to keep dominant personalities from being too stifling. Choose a captain for each team. The magazines will be used as validators and symbols, as well as thought generators.

The chosen teams have a particular length of time to go through the pile of magazines provided. Each team makes a presentation of words and pictures they've chosen that relate to the brainstorming topic at hand. This means the sole use of metaphors as a means of working through questions. For example, when asked to describe the meaning of *precise*, a team might choose pictures that depict the sun shining down on the hood of a car; *limitless possibilities* could be illustrated by a picture of a sunset; or *journeys* could be expressed through the image of a long winding road. After each presentation, competing teams are encouraged to support and add to the others' ideas.

• • •

JACK ANDERSON,
Principal,
Hornall Anderson Design Works, Inc.

g Solution:
BRAINSTORM IN SMALL, COMPETITIVE TEAMS

93

NUMBER OF PARTICIPANTS

2, the designer and client in charge of decision making.

NECESSARY SUPPLIES

List with questions, pencil, pen, paper.

• • •

ACTIVITY

Devise a list of up to ten questions or requests for your client in regard to the project. The questions should not be factual or direct. Instead ask questions that allow the client to express how he feels and what message he wants to convey. An example of a question would be, "What are three adjectives that explain the look of your finished piece?" Another question would be, "What are two colors that reflect the target audience for this project?" The important thing is to make your questions creative and not too specific. Set up a meeting to brainstorm the upcoming project, and supply the list of questions to your client prior to the session. Once you sit down together, discuss each answer in depth. In your sketchbook, take notes on the client's elaborations. This procedure will allow you to get inside your client's head. After the session you will truly understand the objective of your project. Your frustrations and overall revisions will be cut considerably.

REALITY

I was dealing with a client who was developing a new department within his company. The company was already branded; however, the client wanted an entirely different look for his new department. That was the extent of the direction I was given. This client was completely vague and basically wanted me to "whip up" some ideas. Considering that I knew very little about the client's industry, I became frustrated. So I created a list of unorthodox questions and set up a brainstorming session. It was a complete success. The list of questions acted as a primer for our meeting. It allowed my client to get in touch with how he truly felt without putting him on the spot. We discussed each question in detail. After the meeting, I knew exactly how to approach the project. I executed my plan, presented it, and it was approved with minor changes on the spot. The success of this project made the client one of my strongest to this day.

• • •

MATTHEW C. CONNAR,
President,
Boost Creative Company

Matthew Connar

Solution:
MAKE A CLIENT-INPUT LIST

C

• • •

ACTIVITY

Designers quickly learn that every client has a different idea of what "good design" is. Brainstorming with your client at the beginning of a project can provide crucial insight into what their assumptions are concerning good design. The problem is, many clients are uncomfortable entering into right-brain, free-flowing, stream-of-consciousness sessions and would rather leave all of the creative work to the designer. After all, that is what they are paying for, isn't it? Therefore, it becomes necessary to trick them into brainstorming with you.

Simply ask questions about the nature of their business or organization. Write down key words and phrases that are specific to their line of work (these words and phrases could be the beginnings of headlines and concepts later on). Ask basic questions like, "What exactly does your business provide its customers? How is your company different from your competitors? What do your customers seem to react to? What are your competitors doing? What colors do you think work best? Do you hate green?" Take notes, lots of notes; it always pleases people to know that their words are being recorded and it makes the designer appear efficient and businesslike. Additionally, look around your client's office and even at his attire; a large amount of insight can be gained by looking at the art people put on their walls (if any), their screensaver, their clothing, etc.

REALITY

Recently, I began a job with a very intelligent computer programmer who claimed to have no creative ability whatsoever. I asked her to tell me about her project in as much detail as I was likely to understand. She was hesitant at first, unsure whether anything she could say about it would really be useful to the creative work I'd be doing for her. Once she started though, her enthusiasm for the project kicked in and she began talking volumes. She even filled her wall-mounted dry-erase board with words and schematics. I took notes as fast as I could, and by the end of the session she had provided me with an incredible wealth of concepts, images and phrases that I was able to use in the creation of the finished layouts. She did 75 percent of the brainstorming for me! And this, from someone with "no creative ability."

• • •

JIM KRAUSE,
Owner, Designer,
Pinwwwheel.net

C Solution:
LET THE CLIENT
WORK FOR YOU

"NEVER TELL PEOPLE HOW TO DO THINGS. TELL THEM WHAT TO DO AND THEY WILL SURPRISE YOU WITH THEIR INGENUITY."

—George S. Patton

Solution:
SET A TIME LIMIT

NUMBER OF PARTICIPANTS
Unlimited.

NECESSARY SUPPLIES
Anything.

• • •

ACTIVITY
Think of a common object and tell everyone what the object is. You have one minute to think about uses for the object. The idea is to get as creative as possible under a time limit. Have everyone write down their ideas and read them out loud.

REALITY
When I did this activity with a group of creatives I was shocked (and a little disappointed) at how boring and not "out of the box" my ideas were. It helped me to realize how stuck in a rut I was.

• • •

SABRINA J. FUNK,
Art Director,
Big Duck Studio

NUMBER OF PARTICIPANTS
2–10

NECESSARY SUPPLIES
Markers and big paper, open minds and good attitude, caffeine and pretzels.

• • •

ACTIVITY
Each Brainforest project begins with one or more group brainstorming sessions. The unique, fun and especially valuable thing about these sessions is that everyone at Brainforest is involved. From the receptionist to the creative director, we all brainstorm together at that first meeting. We don't make the distinction here between "creatives" and "thinkers"—we are all creative thinkers. Although our office is mid-sized (eight full-time staff members), our range of professional expertise, age and lifestyles makes our brainstorming rich and varied.

These brainstorming sessions can take place with the client joining the Brainforest team, or with the team alone. The conference room is prepared by hanging giant Post-its all over the walls and spreading out an array of colored markers on the table.

The session begins with the client service team member responsible for the particular project introducing its general parameters, most notably information about the end user and his/her decision-making process.

The Brainforest staff, clockwise from top left: Nils Bunde, Dian Sourelis, Maggie Lewis, Drew Larson, Sabin West

We then review the basic rules of ensemble, just as an improv troupe might before a show or rehearsal. These include such things as "no judgment," saying "yes, and . . ." instead of "no." And then the fun begins. Members take turns with the markers, and before long the walls are covered with ideas, words, pictures. There is a lot of laughter and an eclectic mix of ideas to then cull down to a half a dozen or so for the creative team to pursue.

• • •

NILS BUNDE,
President,
Brainforest, Inc.

C Solution:
REQUEST THAT "NONCREATIVES" JOIN YOUR CREATIVE BRAINSTORMING ENSEMBLE

NECESSARY SUPPLIES

Books, books and more books, and even more junk mail.

• • •

ACTIVITY

I was working on my self-promotional Web site. I had restarted the Web site design eight different times. It was off-line for almost two years. I had fallen into that "I don't have time for self-promotion" stage—not just because I had so much work, but because I had too many ideas.

Kristie (Turner) Johnson

Now, I have a technique to avoid that problem. I sit down with many different design books and figure out which design example represents the style I want to transform. I then look over the style, close the book and take one item—sometimes it is something as small as a white square—and use that one piece through the whole design project. I will start out looking at a project that I like, but my project is always something completely different and unique.

• • •

KRISTIE (TURNER) JOHNSON,
Graphic Designer,
Turnergraphics

Solution:
DON'T LET TOO MANY
IDEAS GET IN THE WAY

a

NECESSARY SUPPLIES

A head. An ocean helps. If needed, any reference material available. Anything: music, videos, TV—well, maybe not TV—papers, books, magazines, packages. Your mind will find what will click for you. It need not even relate to your problem.

• • •

ACTIVITY

Stare. Remove everything from your head. Sketch what comes up.

REALITY

Looking out of my window, I saw, as if for the first time, the Hollywood sign. I doodled the logo for the movie *Ed Wood*. A hack old idea, using that sign, but it was appropriate for that story of the worst of Hollywood.

Another time, I was stuck in a hotel in Hawaii in the rain, and a client called for an ad. All I had to get me thinking was the yellow pages. The yellow pages just did not get it up for me, so I had to do it by myself. And I did, by daydreaming. I created one of the Gotcha ads that took them from a garage in Laguna Beach to over $200 million a year in retail sales.

This is also where the tuxedo, white socks and white glove for Michael Jackson came from. He was a young kid going solo. I felt he was going to be the biggest thing in show biz, and I needed a symbol to say that. A metaphor. A visual metaphor. I always remember, from TV, the biggest entertainers opening in Las Vegas in a tux. Michael loved the idea of the tux to signal his debut as a single. How about white socks like Gene Kelly wore in the musicals to show off his dancing feet? So we did socks. And like Kelly did, I had Mr. Jackson pull up his pants to show the socks. We just had the greatest costume designer do the socks and the glove—Bob Mackey. I asked Mr. Jackson what he wanted, and my mind's library reference gave us the answer. I got there by concentrating *and* imagining.

• • •

MIKE SALISBURY,
King,
Mike Salisbury llc

Solution: DAYDREAM

Designer Mike Salisbury says you can use anything around you for inspiration—except maybe TV. (Photo courtesy of Randy Gunter.)

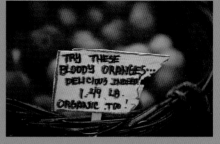

In the spirit of the creative pilgrimage, Mark Sackett created Brainfood Creative Programs and the "Bay in a Day" program, a morning and afternoon of observing and researching the artistic wonders of the San Francisco Bay Area. These two pictures are from a thousand-image archive Sackett keeps of inspirational sights from the program.

Solution: a
TAKE A CREATIVE PILGRIMAGE

• • •

"Trips to see the Dalai Lama are tough to fit into today's schedule," says Gil Haslam, creative director at Novocom. He suggests taking short trips to more reasonable destinations for the purpose of spurring creative energy. "True creativity touches all the senses, so I surround myself in some of the creative elements. This may mean going to the fabric store to check out textures, the bookstore for both classic and contemporary design examples, or a furniture store for functional design. Sometimes it's as easy as taking a new route to work and noticing the sights, signs and sounds along the way. With shorter time frames allotted for creative pilgrimages, you have to turn some of what you do every day into a pilgrimage."

Other designers like to voyage to flea markets, international grocery stores, trendy home décor venues and toy stores. Still others like to have the pilgrimage come to them by subscribing to various magazines and product catalogs. One method is to join a book club with a variety of book topics, and start a shelf of whatever random books come through the mail. Each time you need a quick immersion in "something different," you can pull a book off the shelf and learn something new.

Also, collect artifacts from your creative pilgrimages. Surround yourself with objects that remind you of experiences you've had, or that are simply odd and inspiring in their juxtaposition.

• • •

NECESSARY SUPPLIES
Pencil, pen and paper.

• • •

ACTIVITY
Start by writing your main subject in the center of a piece of paper. Draw a circle around it and then draw five to ten appendage lines extending from the circle. These lines are your subcategories. They can be as simple as who, what, when, where and/or why, or you could make it more specific to your subject. Make similar spokes coming from each subcategory, and list single words you think of that pertain to your subcategory subject. These words should be random nouns, verbs or adjectives.

Using this process, you are basically thinking in ink. When you are finished, you will have a full web of ideas. It will provoke thought and can give you a good base from which to start your research.

REALITY
The first time I implemented mind mapping was in my senior year of college. I had a topic for my thesis, but I didn't know where to begin. After some encouragement from my professor, I began working my thoughts out on paper. What began as a jumbled mass of words in my sketchbook turned into an organized reference point for the rest of my project. I looked to my map for everything from my poster theme to my hyperlinks to my multimedia presentation. Now I use this exercise for a majority of the large projects that I work on, even before I start sketching out ideas.

• • •

MATTHEW C. CONNAR,
President,
Boost Creative Company

a Solution:
MAKE A MIND MAP

"CREATIVITY IS A DRUG I CAN'T DO WITHOUT."
—CECIL B. DEMILLE

101

Daily
CHALLENGES

THOUGH YOU LOVE YOUR JOB, YOU PROBABLY DON'T LOVE IT EVERY MOMENT OF THE DAY. IN A BUSINESS THAT REQUIRES YOU TO BE PERPETUALLY "ON," THOSE "OFF" MOMENTS CAN SEEM MAGNIFIED, AND THE CONSEQUENCES DIRE. FOR EXAMPLE, IF YOU DON'T HAVE A GREAT IDEA FOR YOUR NEW SELF-PROMOTION WEB SITE SOON, WILL YOUR BUSINESS FAIL? PROBABLY NOT, BUT IT WILL FEEL LIKE IT DURING THOSE MOMENTS IN WHICH NEW IDEAS JUST WON'T ARRIVE.

MOST DESIGNERS ARE COMPULSIVE MULTI-TASKERS. IF THERE AREN'T AT LEAST FOUR DIFFERENT PROJECTS TO ENGAGE YOUR ATTENTION AT ANY ONE TIME, YOU START TO FEEL AS STALE AS TUESDAY'S BAGEL. ON A SMALLER SCALE, "STALE" MOMENTS CAN HAPPEN SEVERAL TIMES A DAY. WHAT DO YOU DO WHEN BEING CREATIVE TO DEADLINE BECOMES A SEEMINGLY UNSURMOUNTABLE CHALLENGE? IN THIS SECTION, SEE HOW OTHER DESIGNERS GIVE THEMSELVES THE NEEDED KICK TO OVERCOME STALE MOMENTS. LEARN ABOUT THE BENEFITS OF CHANGING YOUR PERSPECTIVE AND YOUR SCENERY, JOLTING YOUR SLUGGISH BODY BACK TO LIFE, AND TAPPING INTO YOUR CREATIVE ENERGY.

• • •

No matter how many colorful posters are on the walls or how many Karim Rashid chairs are in the lounge, your studio will not always be the energizing space you need it to be. As creative people, you and your team need lots of visual stimulation to feed your brains. Many design inspirations have been the direct result of a simple exploratory trip outside of one's usual environment.

Sometimes, when the walls of your studio seem oppressive, it's best to step outside or take a field trip. "To get the creative juices flowing, I must get away from my home office," says designer Jeff Fisher. "That may mean working in my garden, going for a drive, riding my bike, visiting a local gallery or meeting a friend for coffee."

Joshua Swanbeck of Liquid Agency, Inc., likes to simply take a walk, as does Stefan Sagmeister. The staff at Sayles Graphic Design takes an excursion to the craft or hardware store. Mikey Richardson at Amoeba Corp. steps onto his fire escape, while Jason Burton at Know Name Design might hop into his car to drive until he sees something he hasn't seen before. The goal is to see something new and enliven your senses.

Try to hold your group brainstorms in a different place every time. Check local coffee shops or restaurants for available community rooms. Make a list of parks and other venues for warm-weather ideation sessions. Even rooms at the local gym or space at a nearby lodge, beach house or farming cooperative can be utilized.

Another benefit to stepping outside your studio is that it gives the professional half of your brain a break. Sometimes ideas simply need to incubate, and staring at your studio walls will not speed the birthing process. "I tend to believe that our mind knows the answer to problems fairly quickly; it just needs some time to remember," says Stephen Fritz of Olive. "By taking time off from thinking about it, you're allowing your mind to draw upon everything that you already have stored in your mental notepad. It lets your brain remember what is appropriate and relevant to the task at hand. All you need to do is pay attention when your mind remembers."

• • •

Creative Challenge:
YOU CRAVE A CHANGE OF SCENERY

NECESSARY SUPPLIES

Pad of paper, writing instrument, books, magazines, laptop or none of the above.

• • •

ACTIVITY

Working in the same place day after day can lead to a stale mind. I almost never do my initial creative searching while seated in front of my desktop Macintosh. As a freelancer who works from home, I prefer taking my sketch pad and/or laptop to another room or, better yet, to a coffee shop where I can brainstorm in a fresh environment. When I worked in an agency, I used to take my sketch pad into a vacant conference room or unused area of the office. When I change my environment, my thinking expands and changes, as well.

REALITY

As I mentioned above, I do almost all of my brainstorming away from my home office. I enjoy the peripheral stimulation that exists in some of the local coffee shops around town: people coming and going, music playing, sounds, smells. I try to find a table that is semi-secluded so that I don't feel like I'm "on display" while I fill my sketch pad with scribbles. And I try to buy at least one drink or goodie every hour so that I

don't appear to be loitering and thereby gain the wrath of the shop's employees. Since I live in a relatively small town, I "rotate" coffee shops because I end up talking with the "regulars" too much (at the expense of getting my work done) if I become too much of a regular myself.

• • •

JIM KRAUSE,
Owner, Designer,
Pinwwwheel.net

Jim Krause

Solution:
FIND LOCAL ESCAPES

> # "MAN IS A CREATURE OF HOPE AND INVENTION, BOTH OF WHICH BELIE THE IDEA THAT THINGS CANNOT BE CHANGED."
>
> —TOM CLANCY

Solution:
EXPLORE OLD HAUNTS IN A NEW WAY

g c

NUMBER OF PARTICIPANTS
Any number can play.

NECESSARY SUPPLIES
Transportation to the location, journals, pens, single-use cameras.

• • •

ACTIVITY
Take everyone to a familiar intersection, one that they all use frequently or that represents a generic intersection (one with a McDonald's, a supermarket and so on). Give everyone a journal with only ten pages in it and one word on the cover, like *Leadership*, *Creativity*, *Communication*, depending on the focus of the group. Then give everyone a pen or camera. I usually have a grab bag to determine who uses what medium. Everyone has to find ten things at that intersection that they all would normally take for granted, and redefine it from the viewpoint of the one word on their journal.

The point is to think out of the box and get people talking. Having a visual reminder of why two french fries represent leadership can be a very funny exercise in communication. By the end everyone feels empowered within his or her own definitions of creativity, using the medium they picked out of the bag.

There are no wrong answers in the exercise, and no one can fail, unless they really can't tap into anything in their life. (I always carry a spare Prozac for those rare instances.)

REALITY
Once while doing this exercise with a group of CEOs, the manager of a local store called the police complaining that a suspicious group of escaped mental patients was roaming around his parking lot, scaring shoppers. Didn't we all love that!

• • •

ANDREW J. EPSTEIN,
Senior Designer,
Edward Lowe Foundation

Here, a volunteer with Art with Heart helps a child create a masterpiece.

A volunteering event is an opportunity for a change of scenery—and a change of outlook. If there are no design- or art-related volunteer opportunities in your area, organize one yourself. Steffanie Lorig of Hornall Anderson Design Works, Inc., runs a charity called Art with Heart through her local American Institute of Graphic Arts (AIGA) chapter. She says that the workshops she hosts are "by far the most compelling and inspirational three hours I spend in my normal yearly activities."

Lorig and other designers use their knowledge of creative techniques to teach children about art. "The message is that they can do art anywhere, at any time, with anything. These workshops are fun and inspirational, leaving the kids with the pride of accomplishment." The benefits designers see from these volunteering efforts are grand, as well. Lorig says they leave the workshops with "a renewed sense of purpose, a sense of community and a renewed interest in materials they may have forgotten about."

"JOY IS BUT THE SIGN THAT CREATIVE EMOTION IS FULFILLING ITS PURPOSE."
—Charles Du Bos

a

Solution:
VOLUNTEER YOUR TIME

NECESSARY SUPPLIES

Full tank of gas, or good walking shoes; a phone book if you need to find specific addresses or call for hours.

• • •

ACTIVITY

When brainstorming about a specific project, choose a location or activity that is related. For instance, if asked to design an invitation to a western-themed event, visit a farm or barn. Interact with tactile materials—wood, rusty tools, barbed-wire fence, leather coveralls. See if you can get materials to take back and integrate into the project. For instance, leather strips become the binding; wood from abandoned barn walls becomes the box that the invitation mails in.

REALITY

For an invitation to a historic hotel's seventy-fifth anniversary, we had the idea to create a scrapbook of the hotel's history. The idea was modified to be a cigar box like you would have found seventy-five years ago, filled with memorabilia from a previous stay at the hotel. We visited the local historical society to find out about the hotel's history. We went to the city newspaper's archives to unearth photos and details of events that had taken place at the hotel and the surrounding city blocks. We also reviewed popular graphics from the era of the hotel's opening, and as a result designed several components: a do-not-

disturb sign, a valet baggage tag, a matchbook. Many of the historic photos and the "new" souvenirs were gang-printed on a heavy paper in faded colors, trimmed and stuffed into a cigar box with skeleton keys and buttons found in an antique-shop hunt for travel memorabilia. Over 75 percent of those invited to the gala celebration attended, and years later we still see the invitation on recipients' credenzas and bookshelves.

• • •

JOHN SAYLES,
Creative Director/Partner, and
SHEREE CLARK,
Director of Client Service/Managing Partner,
Sayles Graphic Design

John Sayles and Sheree Clark of Sayles Graphic Design visited the past to get ideas for this invitation for the Hotel Fort Des Moines.

Solution:
BRAINSTORM IN A PLACE THAT FITS YOUR THEME

g

"CREATIVITY CAN SOLVE ALMOST ANY PROBLEM. THE CREATIVE ACT, THE DEFEAT OF HABIT BY ORIGINALITY, OVERCOMES EVERYTHING."

—George Lois

• • •

"My wife, Dorothy, has known me since long before I was a graphic designer (she was my high school sweetheart), and she is not a designer herself," says Michael Bierut of Pentagram. "She makes a great bullshit detector, as do my three smart kids. I think that the more graphic designers surround themselves with normal people, the better off they'll be."

When you surround yourself with normal folks, make sure to draw upon their expertise. Nondesigners can be great as idea bouncers and reality checks.

Bierut has even employed his young daughter to help him with a tricky design. For a poster he was creating for the 100 Show of the American Center for Design, he drafted a slightly mordant list of recurring design styles to answer the question "What is good design?"

"Since the text of the poster was a critique of the overuse of surface style in graphic design, the challenge was to figure out a way to do it that would have 'no style,'" he says. "Because Elizabeth was then about four and a half years old, she knew the alphabet but could not read, and certainly knew nothing whatsoever about graphic design's style wars. I sat at our kitchen table with Liz, gave her a piece of paper and a pen, and dictated the letters one by one. She wrote them down as I read them. She was losing her patience at the end, so I knew I wouldn't get a second chance." Using his daughter's handwriting as the typography for the poster design, Bierut gave a fresh approach to a difficult project.

• • •

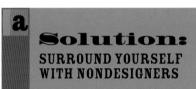

a Solution:
SURROUND YOURSELF WITH NONDESIGNERS

Solution:
SEARCH FOR CLUES

a

• • •

In murder mystery novels, detectives are perpetually searching for clues—tiny details that tell just one part of a larger story. As a designer, you're a detective seeking your next design solution. You may find one part of it in a discarded item on the street. You may find another part of it in a clever phrase spoken by your lunch partner. Look at the world with an all-observing, critical eye. Rich DiSilvio of Digital Vista, Inc., says, "Scrutinize and reevaluate everything. That includes art, media, and all natural and man-made objects the world has to offer, no matter how seemingly unrelated. Don't always expect to find logical solutions in a logical place, as serendipity plays a part in the mysteries of invention."

Observe the colors, textures and movements that surround you when you leave your studio. Pick up the bits of trash on the street that seem compelling. Write down intriguing information you hear. Keep a file of found items, notes and other clues. Go through the world collecting individual clues and items that might help you solve the mystery of your next design dilemma.

• • •

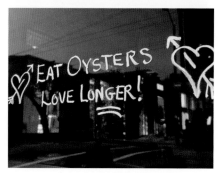

Could these be clues to your next design dilemma? (Photos courtesy of Brainfood Creative Programs.)

Jared Jacob and Lisa Herter

• • •

When your staff needs to brainstorm an idea—or to simply rejuvenate—an off-site retreat can be exactly what's needed. You can relocate for an afternoon, a weekend, or a week, depending on your budget and level of commitment. The best retreats are ones with no mission other than to relax and find out something new about each of your co-workers. It's a casual atmosphere that completely changes the dynamic of your people.

Devoting time to relaxation and exploration encourages your staff to stay connected to themselves and also to build bonds with the others in the group. It helps them stay in touch with their creativity. As Lisa Herter from Ubiquity Design, Inc., puts it, "Creativity is not only a process, but a feeling. Creativity is the rush you get when you create something you love."

When shopping for a place that can feed your group's creativity, look for variety in their facilities. If the goal of the retreat is brainstorming, there should be at east one big, comfortable room—the kind of place where pillows on the floor are completely acceptable. It's also good to find a place close to nature, like a forest lodge, ranch or even an old church with a fabulous, run-over-with-weeds court-yard. The natural world is an immediate balm for the senses, calming and healing a jangled mind.

• • •

g
Solution:
SPONSOR OFF-SITE RETREATS

● ● ●

It happens too often in group ideation sessions—the faces in the room go blank, the shoulders slump, and the group's facilitator must think fast to raise the energy in the room. When your brainstorming group feels tired, frustrated, stressed or otherwise stagnant, one of the best things to do is get some blood pumping. Exercise gets the toxins out of your system and unclogs your mind.

It's as true for a brainstorming group as it is for an individual. Stand up, do some jumping jacks, run around the parking lot, do something to get your blood pumping and your energy back on task.

"When I'm hitting a wall, I put on my walking shoes and go for a brisk walk through the country in the neighborhood where I work," says Eileen MacAvery Kane of Bear Brook Design. "For the first half of the walk, I don't think of anything at all, just meditate. When I am almost done and on the downhill slope, I give some thought to the creative problem I am facing. Ninety-nine percent of the time, by the time I wind my way back, I've figured out a solution." This practical approach—strapping on some walking shoes and getting some blood circulating for a half hour or so—is a favorite solution among designers for an at-work energy slump.

Make movement a policy for yourself and your co-workers, if possible. Look for ways that you can introduce movement into your regular workday, including during brainstorming sessions. The more active your body feels throughout the day, the more active your brain will be.

Try also to break up and vary your exercise across the day: Take a swim in the morning, do some midday stretches, stop by the gym after work, and take a short run with your dog or walk with your spouse in the evening. You don't have to be an athlete, and these activities don't have to take hours upon hours of your time. Even short bursts of physical activity will enliven your cells and get your blood clean and circulating and nourishing your brain. Kim Drury at Artworks Design suggests "getting the blood rushing to your brain for a while," even if it means doing a handstand in the office conference room.

● ● ●

Creative Challenge:
YOUR SLUGGISH BODY NEEDS A JOLT

• • •

Start your work week with an invigorating walking meeting. If your staff gets together every Monday morning and sits around a conference table to discuss upcoming projects, take the meeting on the road. If each person writes their agenda points on an index card that they can carry in a pocket, there's no reason why discussions can't take place while hoofing it along a scenic outdoor route. This kind of activity can also serve as a team-building exercise, giving your staff a relaxed and social atmosphere to trumpet their accomplishments and really "strut their stuff."

• • •

THE BRAIN—IS WIDER THAN THE SKY—FOR— PUT THEM SIDE BY SIDE— THE ONE THE OTHER WILL CONTAIN WITH EASE— AND YOU—BESIDE.

—EMILY DICKINSON

g.

Solution:
TAKE A WALKING MEETING

Solution:
COMBINE WORK
AND PLAY

a
g

The compartmentalized nature of a professional's day does not lend itself to frequent exercise. Work and play are considered very different creatures and have their own hours allotted in the typical professional's day. Exercise is considered recreation, or "playtime." So we sit at a desk all day and then go to the gym for an hour after work. We have inventors and efficiency experts discovering ways to eliminate physical labor from our workday, but then we have big buildings full of physical-labor equipment that we pay to use after work.

To blur the lines between work and play at your studio, introduce recreational equipment like a basketball hoop or air hockey table. Also encourage your fellow staffers to get outside and moving as often as possible. Print out memos and walk them from office to office, rather than e-mailing them. Take the stairs. Have an office-chair race down the hallway. Make Popsicle-stick caricatures of each designer on staff and stage puppet shows, or dance them around the office. Set up an obstacle course of mannequins in the shape of problem clients and other roadblocks for a little comic relief during a hectic project.

• • •

Collin Schneider of Gunter Advertising makes time for a little play in his day.

NUMBER OF PARTICIPANTS
6

NECESSARY SUPPLIES
Six sketch pads and pencils, bowling alley, conference room.

• • •

ACTIVITY
You have one afternoon to come up with a client concept. Everyone seems stuck. You are desperate to inspire your high creatives to produce. Their creative right brains are in desperate need of a vacation. You are going to provide it.

Tell your staff you are taking them in a speeding van to the nearest bowling alley, where they will bowl. Yes, bowl. On company time. They are not to think about the client or the project at all during the game. Their entire focus must be the game and only the game.

Play a short, sweet game, and the losers treat the victors to ice cream. Return to work exhausted but in good spirits.

Tell everyone to take a thirty-minute personal break and then meet in the conference room. You started at twelve o'clock and it's now three-thirty. You are nervous. Will this work? After their break, tell them that they have one hour to come up with the greatest idea ever.

They've been in a right-brain activity all afternoon; now ideas should come. And they will! You are writing them on sticky notes as fast as you can and sticking them up on the wall as they pour out of every-

one's mouths. By five P.M. you are truly stunned at how brilliant your team is and you are for getting them to this place.

REALITY
I've done this not only by day, but also at midnight for disco bowling. It always produces high spirits and great ideas. People can't contain themselves. They let loose, feel invincible and have amazing ideas. They come up with great bowling names for themselves like *Madame X* and *Princess of Power*. It's amazing what putting people in a different environment with a common goal and a right-brain activity can do for their creativity.

• • •

LORIE JOSEPHSEN,
Director,
Otherworld Designs

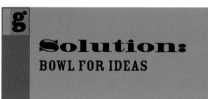

Solution:
BOWL FOR IDEAS

Lorie Josephsen of Otherworld Designs looks for creativity at the bowling alley. Featured here is her dream team, the Steel Magnolias: Suzanna Shantz, Angela Stewart Young and Jennifer Thomas. Photo by Bart Boswell.

"CREATIVITY IS INVENTING, EXPERIMENTING, GROWING, TAKING RISKS, BREAKING RULES, MAKING MISTAKES, AND HAVING FUN."

—MARY LOU COOK

NECESSARY SUPPLIES
You and your naked body

• • •

ACTIVITY
Get naked. Jump up and down in front of a mirror. Play with different parts. Give them goofy names. If you are not laughing and thinking "outside the box" by the end, there is no hope for you.

REALITY
We were working on a project for kids. We needed to think of quotes for this little animated bus. When a vehicle talks, really, it can't be taken too seriously. Nothing that a little birthday-suit ballet couldn't handle. Thus was born: "It's daylight we're losin', so let's get cruisin'." (quote from Gus the Bus)

• • •

HANNAH LOGAN,
Office Manager/Resident Spaz,
Harvest Moon Studio

Solution:
DO SOME NAKED JUMPING JACKS

Harvest Moon Studio created the Gus the Bus character for the Children's Hospital of Los Angeles.

CONOVER INVITES YOU

TO A ROLLER RINK

skate party

Memorial Weekend
Sunday May 27th
6:30pm to 9:00pm

Kids, spouses & significant others welcome
Free rollerskates. Rollerblades are $3 extra
No host snackbar

RSVP to Dave @ 619-238-1999 by May 18th

David Conover created this invitation for a client roller-skating party.

NUMBER OF PARTICIPANTS
100

NECESSARY SUPPLIES
Roller skates and roller rink.

• • •

ACTIVITY
Rent a roller rink. Invite one hundred clients, associates and their families. Open up the snack bar. Put some vintage disco and 1950s music in the jukebox and get rolling! Besides the typical clockwise-skating routine we also supplemented the night's activities with events designed to get people who wouldn't normally associate with each other to interact. We had the famous hokeypokey dance on skates (try putting your whole self out, then shaking it all about in skates!), a group skate where everyone had to hold on to each other in a conga line, and several race events.

It was a classic team-building event that leveled the playing field. The president of the company felt as awkward on skates as the junior designer felt accomplished. A good time was rolled by all.

REALITY
Camaraderie takes form in many unique ways—none more so than when the events of our youth are rekindled. Sometimes a common activity brings employer and employee, client and supplier together to stimulate creative juices in an uncustomary fashion.

• • •

DAVID CONOVER,
principal,
Conover

C

Solution:
TAKE YOUR CLIENTS ROLLER-SKATING

NECESSARY SUPPLIES

Dirt, garden tools, appropriate clothing, gloves, plants, good advice and a willingness to learn.

• • •

ACTIVITY

To the amazement of friends and family, gardening has become a passion and my best therapy from creative blocks and frustrating projects.

Since leaving home for college, I had never had a yard in which to garden. A few flower pots and window boxes were the extent of my gardening experience.

Three years ago my partner and I bought a house with a yard in need of more than just a little tender loving care. With clients like the nationally recognized Joy Creek Nursery, horticulture photographer Janet Loughrey and National Public Radio's "Doyenne of Dirt" Ketzel Levine, I was soon developing an interest in the pastime—and getting lots of advice in the process. Graphic design work for Joy Creek developed into a trade situation for landscape services and plants.

Rain or shine, gardening has become the best way to get away from my computer, put my mind on "self-clean" and open my thoughts to whatever may come my way.

REALITY

As a young boy, there was nothing I hated more than doing yard work chores assigned by my parents. My sister and two younger brothers detested the job just as much. I remember a discussion between my siblings and me, as young kids, when we came to the conclusion that the only reason my parents had four children was to have someone to take care of the gardening responsibilities. Doing the same work for neighbors was not quite as bad. At least I got paid for those efforts.

Now, I love working in my garden. The biggest drawback is people interrupting my work when they stop by to ask the name of a specific plant in full display. That problem seems to have been solved with the plant labels my partner got me for my birthday. People now bring notepads when walking by our house to write down names of plants they like.

• • •

JEFF FISHER,
Engineer of Creative Identity,
Jeff Fisher LogoMotives

Jeff Fisher

Solution:
PLAY IN THE DIRT

a

• • •

Practices that help us become more in tune with our bodies—like meditation or nutritional therapy—are now more widely accepted by the mainstream medical establishment. Some therapies are accepted even in the workplace, like massage.

Karen Handelman of 501creative started a tradition of "Massage Tuesdays" at her firm. "When I was graduating from college, I went on some studio tours in Chicago. One studio we visited was Kim Abrams's, and she mentioned that once a week they had a massage therapist come give neck and shoulder massages. I told my friends that if I ever had my own studio, we were going to adopt that tradition. Now it's thirteen years later. I have a successful business and for five years, Nancy, our massage therapist, has been a regular part of the office. She and her husband even come to our year-end employee celebrations!

"I truly believe that massage makes us not only happier, but healthier," Handelman says. "When someone is feeling sick, Nancy works our immune system pressure points. It helps immensely with the neck and shoulder pain I used to get from sitting in front of the computer too long. My employees love it. Our clients—whom we some-

Masseuse Mary Leonard plies her trade—and the overworked muscles of the staff at Gunter Advertising—once a month. Here, business partner Cindy Gunter enjoys her monthly rubdown.

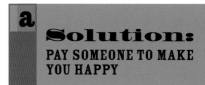

a Solution:
PAY SOMEONE TO MAKE YOU HAPPY

times invite over on Tuesdays for free massages—love it."

Look for opportunities to bring alternative therapists in to your work environment to ply their trades. A once-a-week massage session will do nothing but good for you and your workers. Listen to Handelman's endorsement: "After health insurance, I think it's the best benefit I could offer my staff."

• • •

Creative Challenge:
YOU CAN'T TAP INTO YOUR CREATIVE ENERGY

• • •

You know the days when you feel most creative. Those are the days on which you are wholly consumed by your task, your few glances at the clock are hours apart, and your energy is unflagging. You know what it feels like to hear the quitting-time buzzer and feel like you've only just begun, because your brain is still riding the wave of brilliance that's been propelling you through your day.

You also know the days when creativity never arrives. And how the clock crawls.

Part of being a creative professional is learning to recognize the ebb and flow of the creative mind—your creative mind. The work habits we establish for ourselves should absolutely reflect our patterns of creative energy. Some designers can be productive nine-to-fivers, either because they've trained themselves over the course of many years to be so, or because they naturally fall into that creative cycle. Many others—like Mark Sackett, who says "if god meant for us to see the sunrise, he would have made it later in the day"—simply can't be creative on a typical corporate timetable.

"I get up around eight o'clock, and until, like, ten-thirty, I'm pretty much just rolling pencils around on my desk, and organizing things," Sackett admits. "I'm not creatively functional, so mornings are for administrative work. At about eleven A.M., I start wondering where I should go for lunch. It's not until two o'clock that I'm ready to go like gangbusters. From two until nine or ten P.M.—that's when I do my best creative work, that's when the best of my creative ideas come."

It sounds simple, but whenever you work best is when you should work. Forgive yourself for not following the flock of rise-in-the-light, sleep-in-the-dark working masses. Forgive yourself for sitting useless at your desk on days when your creative cycles simply won't kick into gear. Consider it rejuvenation time for the really great idea that must be percolating in the yet-unknown depths of your creative mind.

• • •

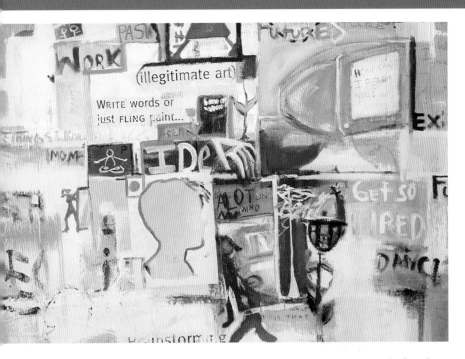

Hannah Fishman and Michelle Hinebrook of StudioFEM hung a 7' x 11' canvas on their studio walls to create this piece of "illegitimate" art—and had a great time doing it. "This illegitimate art was inspired from our perceptions of what 'idea revolution' means to each of us."

Solution:
MEDITATE BY CREATING ILLEGITIMATE ART

NUMBER OF PARTICIPANTS
One or two

NECESSARY SUPPLIES
paint, paper, magazine cut-outs, paper, glue, tracing paper, pencils, tape

• • •

ACTIVITY
This is a form of meditation and has nothing to do with the actual design project at hand. The intent of this exercise is to create a piece of work (traditional or digital) that is made without any pressure. This should release frustrations and let your un-conscious ideas flow. It is meant to be an exercise in intuition and intuition alone. It can be a painting, drawing, collage, digital sketch, or just a sloppy mess. You are not to get attached to this piece of work. You should be dramatic and forceful with your marks, strokes, etc. Write words or just fling paint (whatever you need to do to be loose) and remember that you will be throwing it away when you are finished, so there should be no reason to be careful or inhibited. Spend anywhere between a half-hour to an hour on this, no longer. Afterwards, you should feel stress-free and ready to focus your mind on something else.

• • •

MICHELLE HINEBROOK,
Illustrator;
HANNAH FISHMAN,
Graphic Designer,
StudioFEM

"CREATIVITY INVOLVES BREAKING OUT OF ESTABLISHED PATTERNS IN ORDER TO LOOK AT THINGS IN A DIFFERENT WAY."

—EDWARD DE BONO

Solution:
RECOGNIZE THE POWER OF THE SHOWER

NECESSARY SUPPLIES
Shower, preferably some water and the piece between your ears.

• • •

ACTIVITY
Stick yourself in the shower, and get all of the dust and rubbish out of your dome piece! Don't think about what concept you need; rather don't think—you'll see the ideas filter in sooner or later.

REALITY
Back in college, we were taught that designers need to be "different" in our approach to thinking. Late one evening, I was trying to come up with a concept for a corporate identity and decided to take a shower. In the quiet isolation of the shower, suddenly I was turning out the ideas and concepts by the dozens.

I have found that it is easier for me to think alone in the shower, bath or pool. You don't have noise or distractions. You just listen to your brain and steal the ideas.

• • •

JUSTIN HATTINGH,
Graphic Designer,
Indigo Marketing

•••

"One of the most important lessons I learned early on in my career happened when I walked past an art director who had been sitting in various positions at his desk all day," says Mark Wasserman, a creative director at Plinko. "He didn't leave his desk for the whole day, but I also didn't really notice him actually doing anything. By around four P.M., he was still sitting there, not really stalling, but still not doing anything that looked productive. We talked for a bit, and he admitted that it just wasn't 'happening' today. And even though it seems simple, I've come to realize it's extremely important to know yourself well enough to know when things aren't coming together."

It's like the old saying about the square peg and the round hole. No matter how you force it, it isn't going to click into place. Your creativity works the same way. Don't force yourself to be brilliant when you're having a bad-brain day.

•••

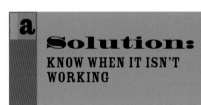

a Solution:
KNOW WHEN IT ISN'T WORKING

When even your gang of desktop friends can't get your mind hopping, it's time to admit you're having a bad-brain day. (This toy parade courtesy of Randy Gunter.)

Solution:
FORGIVE THE DISRUPTION CREATIVITY CREATES

• • •

The award-winning design idea you've been waiting for can come at any time. It might land in your brain while you're in the shower, while you're standing in line at the grocery store or while driving to your next meeting. Guess what? No matter when your idea comes, you have to be ready for it, and you have to be prepared to rearrange your life to capture that idea.

If a rush of creative energy comes over you, you'll have to be willing to leap naked from the shower, leave your groceries in their cart, or postpone that date you've been begging to get for the last six months. The world will forgive you; you're a creative professional, and you get paid to seize creative moments and ride them out. Designer Bruce Turkel says he once drove sixty minutes in the wrong direction because he was busy tracing a logo design idea on the steering wheel of his car.

Forgive yourself for these disruptions. Creative energy does not adhere to any clock and cannot be dictated by schedules.

Many folks who are paid to be creative remind us that these inconvenient bouts of brilliance should always be appreciated. Those people who get them are lucky and should feel grateful. When Stefan Sagmeister was asked if these kinds of manic waves of creativity ever disrupt his life, he responded, "I wish. My life is longing desperately for those kind of disruptions, long-term plans hoping to go awry—to no avail. Waves of creativity refuse to land on my shore."

• • •

"THE THINGS WE FEAR MOST IN ORGANIZATIONS—FLUCTUATIONS, DISTURBANCES, IMBALANCES—ARE THE PRIMARY SOURCES OF CREATIVITY."

—MARGARET J. WHEATLEY

• • •

Some creativity seminars suggest taking a "Secret Mission" every time you notice your energy starting to flag. The method: Take a stack of important-looking papers, set your face in a *I'm-going-to-be-late-if-you-talk-to-me* grimace, and charge around your building looking like you're on your way somewhere. In actuality, you're going nowhere; you're just playing a game with your surroundings. You're not on the way to the conference room. You're using your body's downtime to rev it back into gear and to brush off astonished co-workers.

If you're a designer who works in a corporate structure, fabricated escapes like Secret Missions might be necessary. If your work structure does not, say, have a lounge or a basketball hoop or a Ping-Pong table for daily rejuvenation breaks, you must find some way within the structure of your job requirements to tap into your best energy. Small coping mechanisms like Secret Missions or desk jumping jacks or trips outside to breathe real air can help.

• • •

a **Solution:**
GO ON A SECRET MISSION

• • •

Here's a question for all in-house designers: Does the corporate structure sometimes seem anticreativity?

Sometimes an intelligent argument is all that stands between you and flex-time freedom. If you can present the case for increased productivity on the job through a more diversified work schedule, you might find your work hours more in sync with your natural patterns of alertness.

Present the manager of your area and the human resources representative with evidence on the benefits of introducing flex time for the creative staff. (If you can get other artists on board with your plan, all the better.) You can start by explaining how if you devote only your most alert, productive hours to the job, the quality and quantity of work will be higher utilizing the same amount of hours. Also map out the number of daily interruptions that impede your work, and explain how having some intrusion-free weekend or evening time included in your required forty hours will increase your productivity. Quantify it in terms of lost revenues: "This project took me eighty hours, but with a flexible schedule, I estimate that I could have gotten it done in sixty hours and had time to finish a back-burner project, saving the company X amount of dollars." This will strengthen your argument.

But also be reasonable. Consider all angles. For example, what are the security issues where you work? Your building's attendants may not want the risk of employees in the building after dark, but perhaps an eight o'clock curfew would be reasonable and give you at least a little more flexibility. Suggest a trial period of four months, after which point you can review the flex-time situation with your manager and determine if it has indeed led to better work and more company revenue.

Or, if you're privileged enough to be the principal of your own studio, like Peleg Top of Top Design, create your own version of flex time. Top made a resolution in January of 2000 that he would spend each Friday doing something creative. "I felt that I was getting bored with some of the work I was doing, so I needed to have a personal creative outlet and intake time," he says. "Fridays are usually slower days for us. Though I am still available on the phone to my staff, I try not to step foot in the studio, instead planning personal fun things to do. I take a yoga class, meet a friend for lunch, go shopping, visit a museum, go to the beach, see a play, or get a massage. It's a great time to take care of personal stuff and get ready for a really relaxing weekend."

His productivity hasn't suffered from his choice. "It makes me very focused for the four days I am at the studio. No time is wasted and my schedule is tight and packed. A lot gets done on those four days!"

• • •

Solution:
INTRODUCE FLEX TIME AT YOUR COMPANY

a

"IMAGINATION RULES THE WORLD."

—Napoléon Bonaparte

• • •

"I find that having to mind a clock is like having a tyrant in my life," says designer Patricia Belyea. "Fast-approaching deadlines make me crazy. My heart rate goes up and I feel like I am losing a race—which is not at all helpful in being creative."

When Belyea wants to get a project done right, she chooses to ignore the clock. "When I want to get creative, I pretend I have limitless amounts of time and energy to complete the task. I turn on some music, gently close my door and go into a Zen-like state. Then I can dive deeply into my creative projects."

Other designers find it useful to manipulate time. Projects become much easier to manage when they are segmented into miniprojects. Rather than looking at the complex, overwhelming entirety of the project in front of you, put some time on your side by dividing the project into small segments. Depending on the project, you can divide it into segments like this: research, ideation, experi-

mentation, final design, production, etc. Set short deadlines for each of these stages. It keeps you from becoming overwhelmed and also increases your feeling of accomplishment because you're reaching your goals sooner.

• • •

Patricia Belyea

a Solution:
IGNORE THE CLOCK

"AS THE GREEKS DID, TRY IDEAS SOBER AND DRUNK. BUT DON'T DRIVE."

—Mike Salisbury

Solution: **a**
ASK FOR THE TIME YOU NEED

• • •

One of the biggest blocks to the creative process is time pressure. As deadlines approach, panic rises and creativity plummets. Maya Barsacq of Allegra Design has a simple solution to time pressure: "Ask for the time necessary to allow for the right creative process to occur."

To do this, Barsacq says that she starts each project by demonstrating to the client that "more time will benefit the final product and allow thoroughness in accomplishing a concise marketing and graphic presentation."

Making solid time estimates for how long a job will take is essential with this approach. "I estimate completion of projects based on content, design requirements and production," says Barsacq. "I assess the total require-ments from start to finish and how much labor is going to be involved." Her estimates are usually right on target, giving her enough time to be creative and giving her clients enough warning that creativity takes time.

• • •

Jackson Pollock is an inspiration for p11creative's staff, and so is music. In a space they call "The Pit," there are comfy chairs and a stage complete with lighting, a disco ball, fog machine and sound equipment. "To let off steam, we play music after work," says Leigh White.

• • •

"One of my biggest inspirations is the artist Jackson Pollock. Not necessarily for his work, but for making the process just as important as the art itself," says Leigh White at p11creative. "He allowed his mind to have happy accidents, to dare to follow the roads not taken. He chose to unlearn what he had been taught was 'proper' art. As a result, he turned the art world and the critics into a giant snow globe that he shook often."

Learn to recognize when your art takes a new turn, and let it follow its path. As White says, "Shake the world up, it's OK. It's only advertising."

• • •

a

Solution:
HAVE A HAPPY ACCIDENT

CLUTTER THE MIND VS. CLEAR THE MIND

Randy Goad

Jarrett Hagy

Solution:
BE FOCUSED OR DISTRACTED

• • •

There seem to be two schools of thought amongst designers on the best way to have ideas: Clear the mind or clutter the mind.

Many brainstorming experts recommend surrounding yourself with loads of visuals and new sights—anything different from your usual environment—when you want to come up with ideas. The method is to crowd your brain with stimulation or newness in order to spark your next great creation. It's a process graphic artist Randy Goad from Thunderwith Design calls "self-distraction." He says that when he's pining for an idea, "I'll deliberately do something to distract myself. I'll take time out for watching a movie, or I'll go for a walk, go to the beach and check out the babes, or hang out with some friends for an hour or two." He also fills his head with music or stares at the posters on his walls. It's basically a time-out, a momentary distraction that fills his sights with something new and stimulating.

Jarrett Hagy of Lodge Design Co. says that overcoming creative challenges requires him to "clear things from my mind so I can focus." In this case, distraction is the enemy, especially because distractions aren't always as pleasurable as babe watching. Sometimes, distraction comes in the form of worries about personal issues or anxieties about business changes. When these kinds of negative thoughts crowd your mind, they will take over. Learning to shove those thoughts out of the way and focus is the best remedy. "Focus is the real key to creativity," says Hagy. "I believe that's why many people don't believe they are creative. They can't focus or don't have the mental patience to stay on track with an idea or an area of thought."

• • •

Recognizing your creative times can mean more than setting your office hours appropriately. It also means making sure you have the right supplies on hand to record more unexpected creative outbursts. Fill the spaces where you relax with plenty of supplies to catch your thoughts. Have index cards on your nightstand, a mini notebook in your back pocket when you walk through the park, a voice recorder on the window ledge in your bathroom.

Recording these creative outbursts can be extremely valuable to your career and can even be relied upon to help you when you're stumped or searching for ideas. Even if you are straining and vexing your brain for solutions to your problem, there will be a time when you forget just for a moment that the problem exists, and then the solution will come.

You can become adept at seizing creative opportunities. Make every attempt to externally record ideas as they flit through your brain, but also try to repeat the best ideas to yourself so you'll remember them later. Take heed of this story of a certain creative professional: Struck by a midnight rush of ideas concerning a problem he faced at work, he rolled over in bed to reach his nightstand and recorded each thought on a separate index card. He left the light off so as not to disturb his wife's sleep, and in the morning, he found the index cards strewn across the floor, blank. His pen had been out of ink.

"IF YOU'RE GOING TO BE ORIGINAL, YOU'RE GOING TO BE WRONG A LOT."

—anonymous

a **Solution:**
HAVE SUPPLIES ON HAND FOR CREATIVE OUTBURSTS

• • •

No one wants to waste their valuable work time sitting in a room discussing the same old ideas over and over again. If your company brainstorms are just like your company parties—the same old stories on an unending loop—then that means your group is stuck in a rut. And you desperately need to pull them out.

Probably the best way to get a group thinking in new directions is to alter their perspective. It's the moment that every ideation group facilitator loves—that crystal instant when the group suddenly gets it.

The same way that sometimes an entire brainstorming group needs a brain cleansing, individual brainstormers often need to wipe their minds clean and come at a problem from a new perspective. Sometimes one person can hold back an entire group. We've all heard about the "killer phrases" that are outlawed in brainstorming—phrases like "that'll never work," "we tried that before and it tanked," or "we'll never be able to pay for it." Even just one person who insists on thinking in the same old mode, rehashing old ideas and reliving all the failures of past experiments, can drag down the energy of a brainstorming group. Remember, a room is only as energetic as its most sluggish inhabitant. Energy tends to settle at the "easiest" level, and lazy is easy.

When killer phrases are allowed to enter a brainstorming session, participants start to limit their ideas. "What happens is you go through what I call a self-editing process," says designer Mark Sackett. "You present four ideas in front of a group— and you may have some luck, your ideas may fly—but oftentimes, your ideas get pounced on: 'We tried that before, it didn't work,' 'We tried that two years ago,' 'Someone else did something similar.' Things are ruled out almost immediately. You're just beat to shit, basically. And once somebody starts to self-edit, the best ideas never see the light of day."

Infuse your brainstorming groups and your individual ideation sessions with new perspectives to combat against self-editing and the proliferation of stale ideas.

• • •

Creative Challenge:
YOU NEED TO ALTER YOUR POINT OF VIEW

Stefan Sagmeister

• • •

"I sometimes think about a project starting with a nonsensical statement," says designer Stefan Sagmeister. "For example, if my problem is to design a car, the statement might be 'the car has no wheels.' Using this as a beginning thought, I might arrive at solutions from another angle—even though my resulting car may have wheels again."

Looking at a problem from an opposing point of view is a simple but revealing trick for generating ideas. Individually, you can do as Sagmeister does and work from a nonsense statement. This technique can also work in a team brainstorm. A similar group brainstorm trick is to give the participants two completely opposite objects and ask them to relate those items to the problem you're discussing. It forces brainstormers to think outside their usual realm: "What do an orange and a 1976 Ford Pinto station wagon have to do with the identity system we're trying to design?"

• • •

a
g **Solution:**
LOOK AT OPPOSITES

> **"IF A MAN DOES NOT KEEP PACE WITH HIS COMPANIONS, PERHAPS IT IS BECAUSE HE HEARS A DIFFERENT DRUMMER. LET HIM STEP TO THE MUSIC WHICH HE HEARS, HOWEVER MEASURED OR FAR AWAY."**
>
> —Henry David Thoreau

Solution:
START IN THE WORST PLACE

NECESSARY SUPPLIES

External visual stimuli, books, magazines, computer.

• • •

ACTIVITY

At the start of a project, I typically ask myself, "When solving a problem, what is the one thing the competition would love for you to do? What would give them the advantage?" Sometimes determining what is the worst thing you can do, can end up being the seed and core of the element you most need to protect or deal with.

• • •

JACK ANDERSON,
Principal,
Hornall Anderson Design Works, Inc.

NECESSARY SUPPLIES
Pencil and paper.

• • •

ACTIVITY
We use the writings of Edward De Bono to guide our creative sessions. Everyone in the studio is familiar with his "six hats" theory. (De Bono has written many books, but one of the easiest is *Teach Your Child How to Think*.) The theory is simple and the rudiments can be taught in less than five minutes.

"Let's all wear our green hats now. Green is the color of growth. Let's generate as many ideas as we can. No black hats. Black hats critique ideas. We'll need the black hats later to help decide which of our ideas will work, but no black hats now, okay?"

See how easy it is? Immediately even a large group is brought under control. There are white hats (information gathering), red hats (emotion, no reason necessary), yellow hats (why this idea will work, sunnyside up, the opposite of black), blue hats (summarizing where we are now and where we should go next), and sometimes the troublesome black hats (critiquing).

REALITY
We used this method to name a client's organization. Within a short time, we had dozens of ideas for a new name, including some very wacky ones. When we used the six-hats theory to narrow down the ideas, the group felt satisfied we'd come to the right conclusion. What could have been a nasty meeting run by the most vocal members became a delightful meeting with everyone participating.

• • •

BURKEY BELSER,
President and Creative Director, Greenfield/Belser Ltd.

Burkey Belser

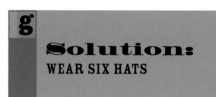

g

Solution:
WEAR SIX HATS

Solution:
COMPARE A PROJECT TO A FAMILIAR EXPERIENCE

C

NUMBER OF PARTICIPANTS
Few.

NECESSARY SUPPLIES
A video/DVD rental card.

• • •

ACTIVITY
Often, when I come across clients who have very strong ideas about what they like, but don't have the creative vocabulary to express it, I resort to the simple question of "If this project were a movie, what movie would it be?" Instead of talking about colors or type-faces, the clients are taken out of the intimidating context of "design mode" and into something more familiar. Who do you know who doesn't have a favorite movie? Everyone does, and it is usually easy for them to talk about it. From that point, you can ask them what it is about the movie that they like. Depending on their answers, you'll be able to fill out those unspoken expectations and derive a look for their logo or Web site. Is it a frivolous comedy? Are the characters in the movie solemn or morose? There is a typeface for every emotion, and colors that match it. If I am unfamiliar with the movie, I go rent it. By the end of the film, I have enough insight into the client's expectations to come up with three or four variations on a theme.

REALITY
One client (an appraisal company) wanted a polished, clean, high-tech-looking Web site designed for straight-forward no-nonsense cus-tomers. I created a few variations based on my assumptions of what would appeal to the intended audience—something relatively modern, but hints of an established, secure background. The client didn't like it. After asking what movie they liked—in this case, the TV show *Star Trek: The Next Generation* came up—I redesigned the Web site, inspired by the control panel designs aboard the Enterprise, and the client loved it!

• • •

C.D. REGAN,
Owner, Designer,
Maelstrom Graphics

"NOTHING IS MORE DANGEROUS THAN AN IDEA WHEN IT'S THE ONLY ONE WE HAVE."

—Émile Auguste Chartier

- - -

ACTIVITY

To spark ideas for a project, imagine being five differently motivated persons. Prepare five pieces of paper with the description of one of the five different persons atop each paper; use age, sex and personality-type descriptions.

Alternately allow each "person" to contribute ideas for a design or art project, or how to see a certain subject matter.

Approaching a problem from five different motivations will sharpen your idea skills, help you focus on unique solutions and expand your appreciation in the process.

- - -

MILES BATT,
Artist,
Miles Batt Studio

a ## Solution:
IMAGINE FIVE DIFFERENT MOTIVATIONS

NECESSARY SUPPLIES

Whatever allows you to sketch or write in abundance.

• • •

ACTIVITY

When we begin a project we usually will start in a way most familiar to us. We invoke habit. Habit is comfortable and known. The problem with habit is that because it is comfortable we sometimes tend not to reach for enough in our brainstorming. We let bosses, clients, peers and even our own self-doubt get in the way of a good idea. We self-edit. Make it harder to invoke your habits. Eliminate the obvious and make your solutions work harder.

REALITY

We once led a group of designers through a brainstorming session during one of our Brainfood Creative Programs seminars. The brainstorming involved them trying to design Christmas products and promotions for a large U.S. retailer. We started by eliminating the obvious. They had to solve the problem without using icons and imagery like Santas, reindeer, holly or trees. We instead encouraged them to talk about what Christmas meant to them. We encouraged the use of alternative types of images that might make the promo-

Mark Sackett. Photo by Ron Berg Photography, Inc.

tions more heartfelt, exciting and unique. The concepts were wonderful and different from what even we expected. I believe it's because they were forced to rethink the approach and avoid habitual creative behaviors.

• • •

MARK SACKETT,
President, Creative Director,
Sackett Design Associates, Brainfood
Creative Programs

Solution:
ELIMINATE THE OBVIOUS

a
g

A panoramic photograph from Burkey Belser's inspiring collection.

NECESSARY SUPPLIES
Camera with a panorama feature and multiple zoom (a Minolta did nicely for me).

• • •

ACTIVITY
Changing the shape of an image changes everything. Using the panorama feature of a camera sets up an entirely new way of looking at the familiar. From landscapes to portraits, everything is suddenly fresh and exciting. But buy lots of film and be ready to use it all. Follow the high reject-to-printable *National Geographic* ratio. Get ready to be sloppy with your horizontal and vertical. Dance with the camera. Turn your experiments into print.

• • •

BURKEY BELSER,
President, Creative Director, Greenfield/Belser Ltd.

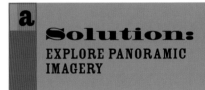

a **Solution:**
EXPLORE PANORAMIC IMAGERY

Solution:

LOOK AT OLD SURROUNDINGS FROM NEW ANGLES

g

NECESSARY SUPPLIES

Pencil, pad, cardboard tube.

• • •

ACTIVITY

The idea of this exercise is to try to view familiar settings from a different perspective and thereby stimulate a new perceptual angle on familiar surroundings. Some methods:

- Use a cardboard tube (like the inner cardboard from a toilet paper roll). Place it over one eye, close the other eye and look around. Notice how differently things look.

- Sit on the floor in a corner where no one normally goes—for example, behind a sofa or plant. Look at the room from this new angle.

- Get up on something high and sit cross-legged, viewing the scene as if floating by the ceiling. See how new it all looks.

- Try closing your eyes and finding your way around a familiar room or rooms. See if you can remember where everything is.

- Spin around in the center of the room a number of times and then watch the room spin around you.

Each time you do one of the exercises above, draw or write something that expresses what you have noticed. For example, when you were sitting behind the sofa, you may have seen the remains of a cookie someone dropped there two years ago; when looking through the cardboard tube, you may have noticed that the patterns on your window blinds look like waves at the horizon on a warm summer day.

Now, in your group, discuss your experiences in detail in a casual forum. Next, get to your brainstorming question, the one that needs to be tackled. Take the experiences you just had and the notes you made and, with the group, visualize the question as if you were doing the same exercises with it, that is, look at it from new angles.

REALITY

I spent a significant portion of my childhood climbing up on high walls or in trees to see what the yard looked like from a different angle, or getting under the house and peering through the cracks in the floorboards to see what the kitchen looked like from the perspective of our German shepherd. When I was older, I started to use these childish techniques to give me a fresh perspective on old problems.

• • •

MICHAEL MCFADYEAN,
Manager,
Sheer Design

Sabrina Funk

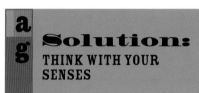

NECESSARY SUPPLIES
Pen, paper, imagination.

• • •

ACTIVITY
Think about your subject. What product are you trying to create? Get it fixed in your mind.

Now think about your subject in terms of all your senses—sight, touch, taste, smell and hearing—and make a list of all the things you think of. For example, if you are creating a brochure for a kennel, think about dogs. Dogs: *furry*, *muddy*, *wet*, *smelly*, *yelping*. If you're alone, make notes. If you're in a brainstorming group, encourage participants to shout as many sensory words as possible, with no hesitation. Have someone write them as they are spoken.

Now while you're thinking of these sensory words you'll also be seeing imagery in your head. Record that, as well.

REALITY
I find that this activity usually just helps me get ideas on the table, ideas that may or may not get developed but are a springboard to a direction and a concept.

• • •

SABRINA J. FUNK,
Art Director,
Big Duck Studio

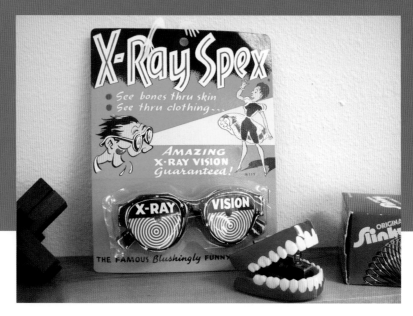

With enough toys or ice cream, our adult facades become transparent. (Photo courtesy of Randy Gunter.)

Solution: g

REVERT TO THE MESSINESS OF CHILDHOOD

NUMBER OF PARTICIPANTS
4–5

NECESSARY SUPPLIES
Ice cream, clothing you don't mind messing up, plastic tarp.

• • •

ACTIVITY
Sit down in a circle, with a couple of good-size tubs of ice cream in the middle. Pretend you are carefree, unsupervised children. Each person takes a turn imagining that the ice cream is something other than ice cream and eating it (with their hands, of course!): "Eeww, worms," big bite. The other "kids" react accordingly. Allow yourself to smear it on your face, clothes, tarp, a friend. Have fun, play, slurp, smear, find the childlike joy.

REALITY
This, I've found, is key to loosening up the "grown-up" hold I often put on my imagination. Sometimes after these activities, we swap our muck-covered clothes for more appropriate business attire and head straight to our computers, ready to channel our playful energy into idea generation. Or sometimes, we stay on the sticky plastic tarp and sketch our ideas for our design project. After we have some sketches, we call it a day and congratulate ourselves for being so clever.

• • •

HANNAH LOGAN,
Office Manager/Resident Spaz,
Harvest Moon Studio

NUMBER OF PARTICIPANTS

This recipe calls for one designer, sprinkled with as many clients as necessary. Season to taste.

NECESSARY SUPPLIES

Sizeable conference table, giant pad of newsprint, markers, colored pencils, crayons.

• • •

ACTIVITY

If after an initial client meeting there are strong indications that the clients have their own "ideas," it is sometimes helpful to get their input before starting on a project. We welcome them into our office, sit them down at our big table and bring out the newsprint, markers and other drawing mediums. Sometimes the clients are a little nervous, but with our encouragement, they always warm up. Especially after we tell them about "Pat."

Deep down in everyone's heart, there is a little artist hiding. Here at Artworks Design, we like to call this person Pat. Now, we bring Pat out only on special occasions, as sometimes he can be a little controversial.

Ask your clients what Pat would draw and have them sketch any ideas they might have. It is best to get these feelings out now. Nothing is worse than when a client takes your initial comps and says "what I was really thinking" and proceeds to draw on them. We feel that having Pat be the artist brings out any feelings and thoughts the clients may have that will be useful to the project.

Artworks Design staff: K. Sonderegger, Kim Drury, Mandy Roberts, Michelle Adams

REALITY

One of our clients wanted to be closely involved with the project—a little too close. After hours spent with the client in the office, looking over the designer's shoulder and actually taking a marker, drawing on the monitor and then wiping it off with his fingers, the designer had to take action. The next time the client visited, the designer was armed with a sketch pad and pencils, and the client actually enjoyed doodling while the designer was able to finish things up. Not that the finished product resembled what the client had drawn, but, hey, it sure made him happy.

• • •

KIM DRURY,
Senior Designer,
Artworks Design

C Solution:
CREATE AN ALTER EGO

NUMBER OF PARTICIPANTS

8–10

Use people from all areas of the office.

NECESSARY SUPPLIES

Stacks of magazines of all different subjects, such as life, recreation, finance, sports, etc.; paper and pens.

• • •

ACTIVITY

First, I pull a variety of people from all of the different disciplines of our office, as well as from various levels of expertise. We all sit in a circle, and I verbally set up the problem to be solved. Going around the circle, each person quickly describes their first impression regarding possible approaches to solving the problem. We all then disperse for about six hours, a relatively short period of time, with the goal to separately go through the stack of magazines. Then, as a group, we come up with a total of twelve different approaches and written concepts of ideas, as opposed to a sketched design. The intent is to keep everyone from hiding behind "visual" curtains. The magazines are used not to come up with design and graphic concepts, but rather as reminders of the world we live in. We then edit down the ideas to five or six that we feel are most on target and strategic and that have the most successful application and extension factors, and then take those ideas to the storyboarding process and through to the actual design.

Solution:
FOCUS ON IDEAS, NOT DESIGN

g

REALITY

We first used this approach when working on a new client's Web site. What made all of the difference was the written concept versus the visual one made from focusing on drawings and colors. Often, one forgets that a design really has no concept if it is solely comprised of the visual. If you can't articulate what the concept is, there likely isn't a concept to begin with. The discipline of initially writing the concept, rather than sketching it, really ferrets out the decoration from the right idea. This brainstorming exercise relies on three main components: the written element—a test of whether the outcome is a concept or just a design; the people involved—should be a variety from different disciplines; and the time frame in which to accomplish the exercise—an extensive amount of time is not necessary for a written concept or description, unlike what's needed to actually draw an idea. By using this form of exercise, we are able to successfully express the exact feelings and ideas of what the client stands for. We then translate the idea into a design and message that reflects not only the company's business, but the entire experience.

• • •

JACK ANDERSON,
Principal,
Hornall Anderson Design Works, Inc.

STEPS

1. Print the word *tree* on one side of a vertical sheet of paper.

2. Random words or things are selected by each participant from the immediate environment (*floor*, *ceiling tile*, *chair*, *window*, *collar*, *shoelace*, etc.) or from the imagination (*dice*, *mousetrap*, *fox*, *ripple*, *cupcake*, *blue*, *straight*, etc.) and are listed from top to bottom on the opposite side of the sheet.

3. Methodically draw a line from the single word on the left (*tree*) to each of the words on the right. Each new combination presents association versus disassociation or similarity versus opposition.

4. Using the prompts from this list, a new frame of reference is explored through group visualization of design possibilities. Group visualizations begin by asking questions like, "How is a tree similar to a ball of yarn?" or "How is a tree different from a chair?"

This creative exercise encourages artists to make connections and explore possibilities more fully.

• • •

MILES BATT,
Artist,
Miles Batt Studio

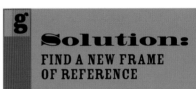

g
Solution:
FIND A NEW FRAME OF REFERENCE

Miles Batt created this transparent watercolor after conducting his "invent a tree" activity.

NECESSARY SUPPLIES

Watercolors, sketch pad, computer (if desired).

• • •

ACTIVITY

Participants are given the problem of "inventing" a tree or other common object.

Solution:
ACT OUT YOUR DESIGN

NUMBER OF PARTICIPANTS
One for each letter in the logo you need to design, plus one amateur photographer.

NECESSARY SUPPLIES
One white T-shirt for each person, permanent marker, digital camera.

• • •

ACTIVITY
This solution is great when developing a logo for a client that wishes to use an acronym for the organization's name. Choose a person to represent each letter of the acronym and give them each a shirt. Have them make their letter as big and bold as possible on the front and back of the shirt. (Example: Another Beautiful Client wants to be known as ABC. One person makes an A shirt, the next makes a B shirt, and so on.) Each person of the group needs to assume the personality of his letter. C becomes "Hi! I'm warm, friendly and open because I'm the letter C!"

Here's the fun part: Each member of the group needs to figure out how these letters best work together. Do they stack? Are they side by side? Have the photographer take pictures of the different formations. When you are finished, it's back to the studio. Give the photos to the designers assigned to the project and watch their amazing creations appear before your eyes!

REALITY
We had a client who wanted to use three letters to form a logo. The designers initially struggled with the difficulty of linking these letters together, as two letters were the same and one was very unfriendly. We took this activity outside to the grass. After a few intricate and skillful moves, a few tumbles and lots of laughter, we had some great photos. Not to mention we had some incredible ideas for a logo that would definitely "wow" the client.

• • •

KIM DRURY,
Senior Designer,
Artworks Design

When brainstorming solo, I often will try to enter a meditative state in which I move objects, words or shapes around in my head. This can take several tries with sketching out ideas to solidify or remove them from my brain. When brainstorming, a single word or phrase can be stuck in your thought process. The best way to purge it is to just go ahead and write it down, get it out of your system.

REALITY

In designing a Web site for a photo studio, I sat with my eyes closed and imagined my client and their existing identity. Using their colors and logo, I was able to visualize what I wanted the site to look and act like. Frequently I would open my eyes and sketch out a thought or an idea. Finally I was to the point where I needed to start building the design on the computer in order to refine those ideas.

• • •

BENNETT SYVERSON,
Associate Creative Director,
Gunter Advertising

Bennett Syverson

NECESSARY SUPPLIES
Design books, pencil, eraser, pens, paper, CD player.

• • •

ACTIVITY
Sometimes I use a freethinking, word-association process for both group and individual brainstorming.

I need to get to a "zone" to be successful at solo brainstorming. Quiet is one avenue to get there; the other is music. This depends entirely on my mood and what I am designing or creating.

ag **Solution:**
ALLOW FREETHINKING

"NOTHING CAN BE CREATED, FROM NOTHING."

—Lucretius

Solution:
HAVE A BRAIN HURRICANE

g

NUMBER OF PARTICIPANTS
Unlimited.

NECESSARY SUPPLIES
Construction paper, scissors, tape, colored pens, string and a timer.

• • •

ACTIVITY
To start the "Brain Hurricane," ask all participants to make a thinking cap using the supplies. Give them five minutes to do so. At the end of the five minutes, you have a room full of silly-looking sorts, all laughing at each other. This creates the perfect environment for creative thinking.

Then present the purpose or key question of the meeting and ask the participants to write down as many ideas as possible in five minutes.

Next, collect and then randomly distribute all the papers for round two. Give the people ten minutes to read what the other person wrote and add to it.

Then get everyone into small groups to discuss the ideas. To determine the best and most useful contributions, each group records all their ideas on an easel and then the entire group discusses and debates the results.

• • •

JOSHUA SWANBECK,
Art Director,
Liquid Agency, Inc.

NUMBER OF PARTICIPANTS
5

NECESSARY SUPPLIES
Each person's own mental bank or block.

• • •

ACTIVITY
Ask each creative team member to submit at least one idea by putting themselves into the end user's or customer's shoes.

REALITY
A record label wanted to offer more captivating material to lure and maintain fans visiting their Web site. Each person was asked to act as a fan and offer ideas. As we pretended to be the customer, we agreed that video was an important addition to the site.

Imagining myself as a fan, I felt that attending a live concert was always better than seeing a movie or video, so I opted for naming the video section "On Stage." This way we could periodically announce that a particular band was "Now Appearing On Stage!" It seemed to conjure more excitement and live appeal. It was a go. The original Web page offered a virtual stage setting with lights and amps. Background audio, which I gathered from live performances of bands warming up, with the crowd rustling, was added as an auto-launch file to recreate that live aura generated by a concert. The fans loved it, and the page hits proved it.

• • •

RICH DISILVIO,
President—Artist/New Media Developer, Digital Vista, Inc.

g

Solution:
ROLE-PLAY

"THE ABILITY TO RELATE AND TO CONNECT, SOMETIMES IN ODD AND YET STRIKING FASHION, LIES AT THE VERY HEART OF ANY CREATIVE USE OF THE MIND, NO MATTER IN WHAT FIELD OR DISCIPLINE."
—George J. Seidel

DIRECTORY OF ACTIVITIES

Brainstorming activities and creativity tips are listed according to their most suitable ideation environment: alone, in groups or with clients. Some activities appear in more than one section, because they are suitable for more than one type of brainstorming environment. Icons also appear on each page throughout the book to indicate if the content refers to a solitary, group or client activity.

TRY MODIFYING THESE GROUP ACTIVITIES TO INCLUDE CLIENTS!

DIRECTORY OF CONTRIBUTORS

Jack Anderson
Principal
Hornall Anderson Design Works, Inc.
1008 Western Ave., Suite 600
Seattle, WA 98104
(206) 467-5800
info@hadw.com
www.hadw.com

Kare Anderson
Speaker, Author
Say It Better Center
15 Sausalito Blvd.
Sausalito, CA 94965-2464
www.sayitbetter.com

Maya Barsacq
Owner
Allegra Design
1345 Pine Flat Rd.
Santa Cruz, CA 95060
www.allegra-design.com

Miles Batt
Artist
Miles Batt Studio
301 Riverland Rd.
Ft. Lauderdale, FL 33312

Mary Todd Beam
Painter
Beam Art Studio
125 Cricket Hollow Way
Coshy, TN 37722

Burkey Belser
President, Creative Director
Greenfield/Belser Ltd.
1818 N. St. NW
Washington, DC 20036
www.gbltd.com

Patricia Belyea
Principal, Creative Director
Belyea
1250 Tower Building
1809 Seventh Ave.
Seattle, WA 98101
www.belyea.com

Ilise Benun
Director
Creative Marketing and Management
PO Box 23
Hoboken, NJ 07030
www.artofselfpromotion.com
www.selfpromotiononline.com

Michael Bierut
Principal
Pentagram
204 Fifth Ave.
New York, NY 10010
www.pentagram.com

Nils Bunde
President
Brainforest, Inc.
1735 N. Paulina, #409
Chicago, IL 60622
www.brainforest.com

Jason Burton
Art Director
Know Name Design
5992 Sugarbrush Dr.
Richmond, VA 23225
www.knownamedesign.com

Marcie Carson
Creative Principal
IE Design
1600 Rosecrans Ave.
Building 6B, Suite 200
Manhattan Beach, CA 90266
www.iedesign.net

Steve Circeo
Owner
Maxcreative LLC
6215 Via Corta del Sur, NW
Albuquerque, NM 87120
www.maxcreative.com

Matthew C. Connar
President
Boost Creative Company
3641 Winkler Avenue Extension, Unit 1811
Fort Myers, FL 33916
www.boostcreative.com

David Conover
Principal
Conover
800 West Ivy St.
San Diego, CA 92101
www.studioconover.com

Jane Sayre Denny
Owner/Design Chief
The Mad Hand art, graphics & design
Forest Hills, NY
www.themadhand.com

Rich DiSilvio
President—Artist/New Media Developer
Digital Vista, Inc.
24 Amity Pl.
Massapequa, NY 11758
www.d-vista.com

Kim Drury
Senior Designer
Artworks Design
12825 Flushing Meadows, Suite 104
St. Louis, MO 63131
www.artworksdesign.com

Andrew J. Epstein
Senior Designer
Edward Lowe Foundation
303 E. Wacker Dr., Suite 227
Chicago, IL 60601
www.lowe.org

Jeff Fisher
Engineer of Creative Identity
Jeff Fisher LogoMotives
PO Box 17155
Portland, OR 97217-0155
www.jfisherlogomotives.com

Hannah Fishman, Graphic Designer
Michelle Hinebrook, Illustrator
StudioFEM
15 East Kirby, Suite 621
Detroit, MI 48202
www.studiofem.com

Stephen Fritz
Principal, Creative Director
Olive
305 Second Ave., Suite 522
New York, NY 10003
www.olivemedia.com

Sabrina J. Funk
Art Director
Big Duck Studio
143 W. 29th St., Suite 1003
New York, NY 10001
www.bigduckstudio.com

Randy Goad
Graphic Artist
Thunderwith Design
11115 Sherman Way, #206
Sun Valley, CA 91352

Randy Gunter
Owner, Creative Director
Gunter Advertising
2912 Marketplace Dr.
Madison, WI 53719
www.gunteradvertising.com

Jarrett Hagy
Principal
Lodge Design Co.
9 Johnson Ave.
Indianapolis, IN 46219
www.lodgedesign.com

Karen Handelman
President
501creative
6321 Clayton Rd.
St. Louis, MO 63117
www.501creative.com

Gil Haslam
President/Creative Director
NOVOCOM
12555 W. Jefferson Blvd., Suite 221
Los Angeles, CA 90066
www.novo.com

Andrea Hatter
Freelance Designer
6398 Charter Way
Lithonia, GA 30058

Justin Hattingh
Graphic Designer
Indigo Marketing
61 Corlett Drive
Illovo
Johannesburg
South Africa
www.indigomarketing.biz

Lisa Herter
Creative Director
Ubiquity Design, Inc.
Denver, CO
www.ubiquity-design.com

Kristie (Turner) Johnson
Graphic Designer
Turnergraphics
2211 Piketon Rd.
Lucasville, OH 45648
www.turnergraphics.com

Lorie Josephsen
Director
Otherworld Productions
815 Edwards Rd. #6
Greenville, SC 29615
www.1otherworld.com

Eileen MacAvery Kane
Art Director
Bear Brook Design
97 Helms Hill Rd.
Washingtonville, NY 10992
www.bearbrook.com

Jim Krause
Owner, Designer
Pinwwwheel.net
pinwwwheel@attbi.com

Kelly D. Lawrence
Principal, Designer
Thinking Cap Design
10 College Ave., Suite 200
Appleton, WI 54911
www.thinkingcapdesign.com

Steve Lawton
Illustrator
Air Hero's Studio
4875 Kent Ave.
Niagara Falls, ON
Canada
L2H 1J5

Alexander Lloyd
Manager, Creative Director, General Everything Guy
Lloyds Graphic Design & Communication
35 Dillon St.
Blenheim, New Zealand

Hannah Logan
Office Manager/Resident Spaz
Harvest Moon Studio
3534-A Larga Ave.
Los Angeles, CA 90039
www.harvestmoonstudio.com

Steffanie Lorig
Designer
Hornall Anderson Design Works, Inc.
1008 Western Ave., Suite 600
Seattle, WA 98104
www.hadw.com

Rich McCoy
Head Tinkerer
McCOYdotCOdotUK
25 Aborfield Close
Helpston, Cambridgeshire
United Kingdom
PE6 7DL
www.mccoy.co.uk

Michael McFadyean
Manager
SHEER Design
913 The Gables
174 Victoria Embankment
Durban 4001
South Africa

Carolyn McHale
Principal, Senior Designer
Boldface Design
422 East Street, NE
Vienna, VA 22180
www.boldfacedesign.com

Dianne McKenzie
Executive Producer, Web Architect
Comet Studios
1000 Pennsylvania, Loft #16
San Francisco, CA 94107
www.cometstudios.net

Matt "Pash" Pashkow
Digital Soup
3751 Robertson Blvd.
Culver City, CA 90232
www.digitalsoup.com

David Pearce
Principal
Pearce Designs

C.D. Regan
Owner, Designer
Maelstrom Graphics
86 Williams Ln.
Hatboro, PA 19040
www.maelstromgrafx.com

Mikey Richardson
Creative Director
Amoeba Corp.
49 Spadina Ave., Studio 507
Toronto, Canada
M5V 2J1
www.amoebacorp.com

Mark Sackett
President, Creative Director
Sackett Design Associates
Brainfood Creative Programs
2103 Scott St.
San Francisco, CA 94115-2120
www.sackettdesign.com

Stefan Sagmeister
Sagmeister Inc.
222 W. 14th St., 15A
New York, NY 10011

Mike Salisbury
King
Mike Salisbury llc
PO Box 2309
Venice, CA 90294

John Sayles, Creative Director/Partner
Sheree Clark, Director of Client Service/Managing
Partner
Sayles Graphic Design
3701 Beaver Ave.
Des Moines, IA 50310
(515) 279-2922
www.saylesdesign.com

Carmen M. Smith
Artsiphartsi Gallery
2717 W. Kennedy Blvd.
Tampa, FL 33609

Lanny Sommese
Professor and Head of Graphic Design, Penn State
University
Principal, Sommese Design
481 Glenn Rd.
State College, PA 16803

Andy Stefanovich
In Charge of What's Next
Play
1801 E. Cary St., Studio 200
Richmond, VA 23223
(804) 644-2200
www.lookatmorestuff.com

Joshua Swanbeck
Art Director
Liquid Agency, Inc.
448 S. Market St.
San Jose, CA 95113
www.liquidagency.com

Bennett Syverson
Associate Creative Director
Gunter Advertising
2912 Marketplace Dr.
Madison, WI 53719
www.gunteradvertising.com

Peleg Top
Principal
Top Design Studio
11108 Riverside Dr.
West Toluca Lake, CA 91602
www.topdesign.com

Bruce Turkel
Turkel Schwartz & Partners
2871 Oak Avenue
Coconut Grove, FL 33133-5207
www.braindarts.com

Mark Wasserman
Creative Director
Plinko
155 Tenth St.
San Francisco, CA 94103
www.plinko.com

RaShelle Westcott
Creative Coach
inVision
1801 Dove St., Suite 104
Newport Beach, CA 92660
www.getinvision.com

Leigh White
Marketing/Concept Manager
p11creative
20331 Irvine Ave.
Santa Ana Heights, CA 92707
info@p11.com
www.p11.com

BIBLIOGRAPHY/RESOURCE SECTION

BIBLIOGRAPHY

Clark, Charles. *Brainstorming: How to Create Successful Ideas*. Hollywood, CA: Wilshire Book Company/Doubleday & Company, Inc., 1958.

Maisel, Eric. *Fearless Creating: A Step-by-Step Guide to Starting and Completing Your Work of Art*. New York: Jeremy P. Tarcher/Putnam, 1995.

Michalko, Michael. *Thinkertoys: A Handbook of Business Creativity for the 90s*. Berkeley, CA: Ten Speed Press, 1991.

CREATIVITY BOOKS FOR DESIGNERS:

Kelley, Tom. *The Art of Innovation*. New York: Doubleday/Random House, 2001.

Vrontikis, Petrula. *Inspiration=Ideas: A Creative Sourcebook for Graphic Designers*. Gloucester, MA: Rockport Publishers, 2002.

Krause, Jim. *Idea Index*. Cincinnati, OH: HOW Design Books/F&W Publications, 2000. (800/289-0963)

Oldach, Mark. *Creativity for Graphic Designers*. Cincinnati, OH: HOW Design Books/F&W Publications, 1995. (800/289-0963)

Williams, Theo Stephan. *Creative Utopia: 12 Ways to Realize Total Creativity*. Cincinnati, OH: HOW Design Books/F&W Publications, 2002. (800/289-0963)

GENERAL CREATIVITY BOOKS:

Hall, Doug. *Jump Start Your Brain*. New York: Warner Books, Inc., A Time Warner Company, 1995.

Michalko, Michael. *Cracking Creativity*. Berkeley, CA: Ten Speed Press, 1998.

Michalko, Michael. *Thinkertoys: A Handbook of Business Creativity for the 90s*. Berkeley, CA: Ten Speed Press, 1991.

Maisel, Eric. *Fearless Creating: A Step-by-Step Guide to Starting and Completing Your Work of Art*. New York: Jeremy P. Tarcher/Putnam, 1995.

Ricchiuto, Jack. *Collaborative Creativity: Unleashing the Power of Shared Thinking*. New York: Oakhill Press, 1997.

Wujec, Tom. *Five Star Mind: Games & Puzzles to Stimulate Your Creativity and Imagination*. New York: Doubleday/Bantem Doubleday Dell Publishing Group, Inc., 1995.

CREATIVITY PROGRAMS:

Brainfood Creative Programs

Brainfood is a program designed to provide a creative jump-start for corporations with in-house marketing and creative departments or for anyone who could benefit from fresh and interesting ways to stay abreast of visual and marketing trends.

Contact: Mark Sackett, Brainfood Creative Programs, 2103 Scott St., San Francisco, CA 94115, marksackett@sackettdesign.com

Bay In A Day

Bay In A Day exists in two forms: a 1,000-image archive of places, research and inspiration, and as a day of shopping, eating, looking at and documenting the murals, stores, boutiques, artist studios, and natural wonders of the San Francisco Bay Area. It focuses on identifying emerging retail and product trends. It can be customized to any city and any group's interest or need.

Contact: Mark Sackett, Bay In A Day program, 2103 Scott St., San Francisco, CA 94115, marksackett@sackettdesign.com

INDEX

PERMISSIONS